THE SIMPLE Chinese
Brush Painting

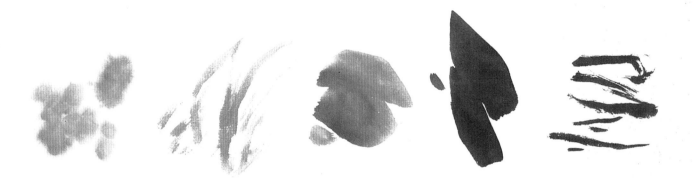

THE SIMPLE ART OF Chinese Brush Painting

Qu Lei Lei

Create your own Oriental flowers, plants, and birds for joy and harmony

CICO BOOKS
LONDON NEW YORK

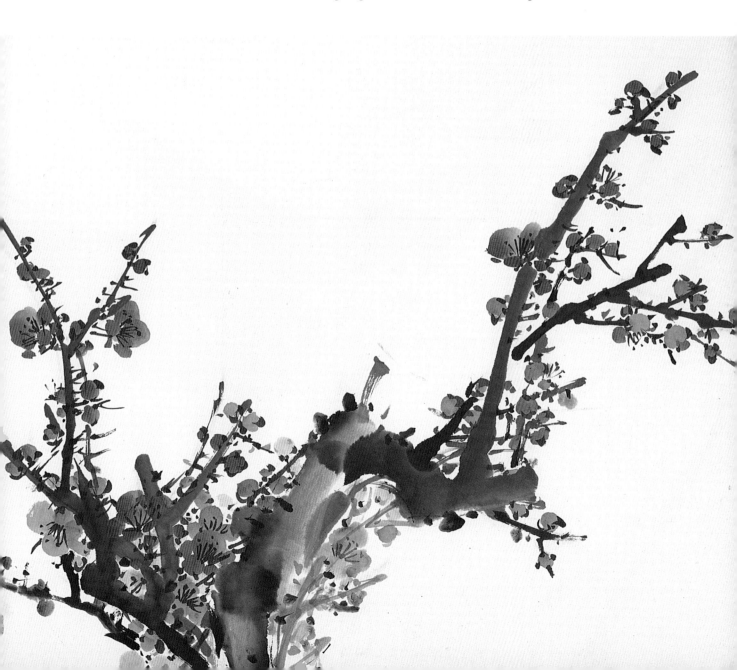

Hardback edition first published in 2004 by CICO Books
This paperback edition published in 2009 by CICO Books
an imprint of Ryland Peters & Small Ltd
20–21 Jockey's Fields, London WC1R 4BW

www.cicobooks.co.uk

10 9 8 7 6 5 4 3 2 1

ISBN-13: 978 1 906525 43 9

Printed in China

Editor and additional text: Robin Gurdon
Designer: Ian Midson
Photographer: Geoff Dann

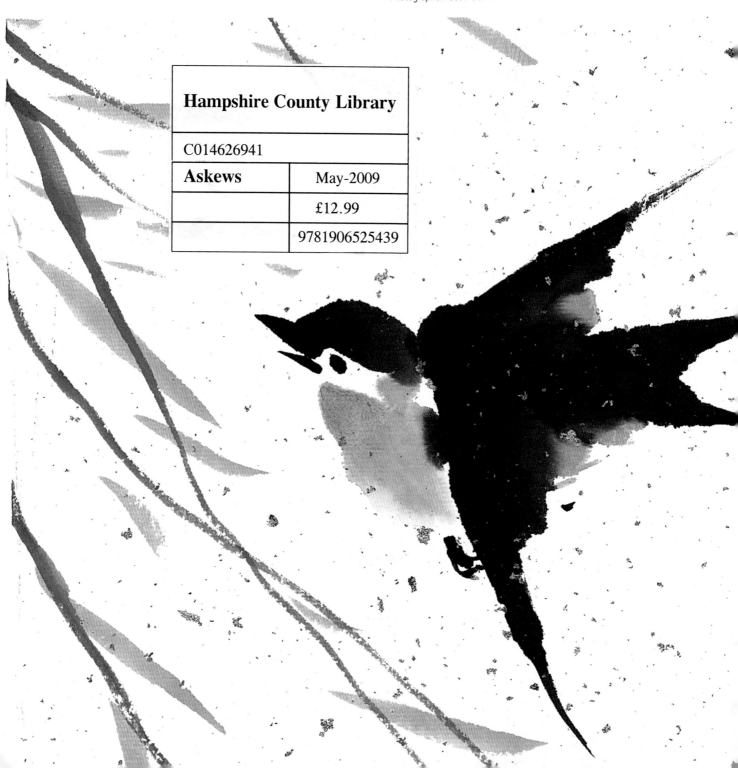

contents

introduction

Best described as a "voiceless poem" or even "soundless music," Chinese brush painting uses ink and color to paint direct studies of the natural world on paper or silk. It differs from western painting in having no particular concern about light and shade; instead, it uses special brush-and-ink techniques to combine the clear representation of the subject's structure with an attempt to express its internal spirit.

Chinese painting divides into three main subject areas: landscape, figure, and the painting of flowers and birds, which also includes all types of animal and plant life. As early as the Han dynasty (206BC–AD220) these individual areas had split apart from each other, and, maturing through the Tang dynasty (618–907) and the Five Dynasties (907–960), they reached their peak during the two Song dynasties (960–1271).

As well as being divided into three areas of subject matter, Chinese art can also be divided into two distinct styles—the Meticulous and the Freehand—which themselves developed from the historical "Academic" and "Literati" traditions.

Academic-style painting (*Yuan Ti Hua*) rose to its peak during the Five Dynasty and Song periods. The importance of painting began to expand when the emperor himself set up an academy at the royal palace, gathering the best painters from all across the country together at court and directly influencing their work. The Academic style's aestheticism is best shown by the great detail of form and color in studies of the natural world, producing peaceful, elegant, and tranquil images.

The "Literati" style (*Wen Ren Hua*) began to develop in the same period. Its objective was not to portray objects realistically but, through the play of brush and ink, to use the painting to show the artist's emotions and philosophical ideas. Then, by combining painting with calligraphy and poetry into a single unit, the idea of the so-called "Three Perfections" was conceived. This theory developed through the Yuan (1271–1368), Ming (1368–1644), and Qing (1644–1911) dynasties, soon taking over from the Academic as the dominant force in Chinese painting. In reality, though, the two styles are sometimes difficult to separate because the greatest exponents of the "Literati" style also had the technical skills to enable them to paint exquisitely detailed subjects.

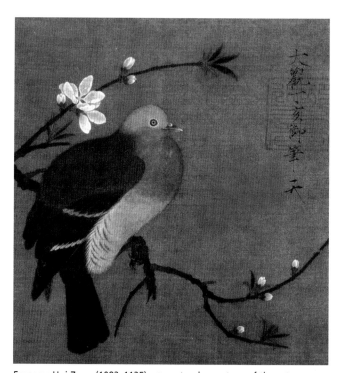

Emperor Hui Zong (1082–1135) was not only a patron of the arts through the academy created in the royal palace but also a great painter himself.

Although the concepts of the two styles are different, the basic techniques used in each are identical.

Of all the plants, the plum blossom, orchid, bamboo, and chrysanthemum have become the basis of Chinese art because of their beauty and characters. The plum blossom is delicate yet hardy, as it blooms through ice to herald the spring; the orchid is peaceful but sophisticated and reserved from the world. Bamboo is tough, upright, and survives all seasons, growing ever upward. The chrysanthemum blooms even after frost and needs no help cultivating itself. Chinese art has adopted them as symbols of the great intellectual ideals, and they are known as "The Four Gentlemen." Sometimes, pine replaces chrysanthemum and is matched with plum blossom, orchid, and bamboo to create "The Four Friends." Both groupings are often accompanied by birds and together they have become the most popular subject for generations of Chinese artists. Because of their differing structures, these plants are particularly suited to Chinese painting, and the mastering of "The Four Gentlemen" is a very good introduction to Chinese brush-and-ink techniques.

Before starting Chinese brush painting, it is necessary to have a clear understanding of the techniques and materials. As the absorbent paper and silk on which paintings are made do not allow any mark to be amended or removed, every brush stroke must be accurate. Brush-and-ink techniques need to be learned and practiced to achieve this, and, as Chinese painting and calligraphy developed from the same source, both require the mastering of brush and ink work. Practicing calligraphy is a good way to start improving painting skills.

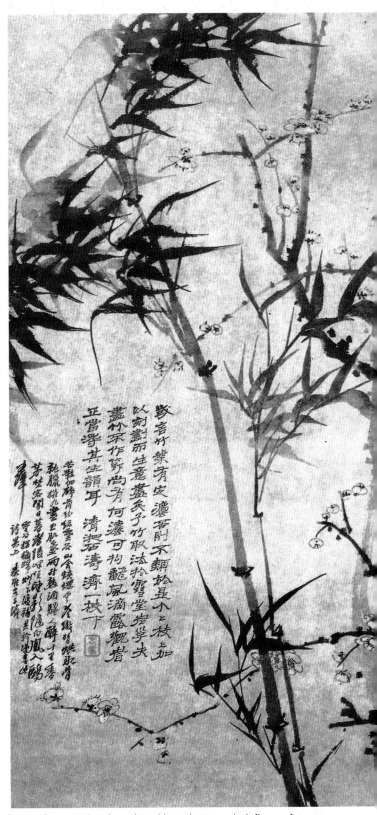

Great Chinese artists throughout history have sought influence from the "Four Gentlemen"—the plants representing the great intellectual ideas. Here, blossom and bamboo are combined by the early Ching dynasty painter Shi Tao (1642–1718) with running-script calligraphy and a pair of seals.

history

Flower and bird painting started to evolve as individual disciplines as far back as the Han (206BC–AD220) and Tang (618–907) dynasties, but very few original works from this period survive to the modern day.

From the Five Dynasties (907–960) through to the Song Dynasties (960–1271), the creation of the Royal Academy, giving direct imperial encouragement for art, elevated the painting of flowers and birds into a golden age. Huang Quan (903–965) was the greatest artist of this period, and his Meticulous style influenced artists for all time. He used line drawing filled with color to paint exotic flowers, beautiful stones, and birds—images suitable for the aristocratic tastes of the court.

In the early tenth century, the earliest stage of what would become known as the Freehand, or "Literati," style began to develop. In placing greater importance on the expression of his ideas and feelings, Xu Xi was no longer copying real items in perfect detail. He drew and painted his subjects directly in ink using only a little color to support the basic composition—the so-called water-ink technique.

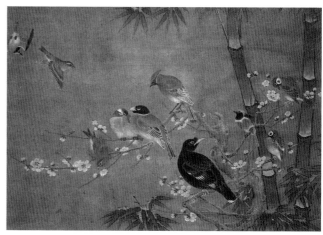

Above: Bamboo blossom and birds captured in a pure Meticulous style by the great tenth-century artist, Huang Quan.

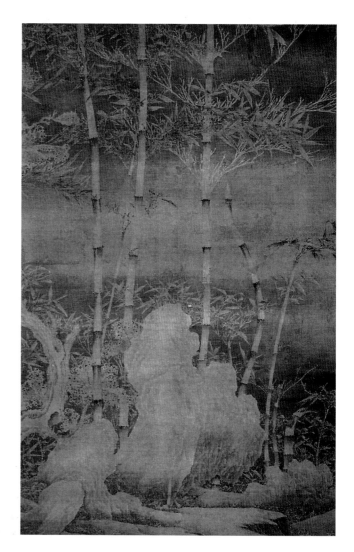

Right: Xu Xi's tenth-century image of bamboo in snow captures one of the first moments when artists painted emotion as well as capturing perfect detail.

Many great artists flourished during the Northern Song dynasty (960–1127), when Academic painting remained the authorized style. Zhao Chang (early eleventh century) had such mastery of the use of paint that his studies of flowers and birds are said to be almost perfect examples of the Academic style.

Meanwhile, the growth in number of intellectuals involved in painting ensured that water-and-ink Freehand painting also flourished. The famous saying of Wen Tong (1018–1079), one of the greatest painters of bamboo, best captures the importance the "Literati" painters now placed in personal expression over pure realism: "Before the brush touches the paper, the bamboo is already in your heart."

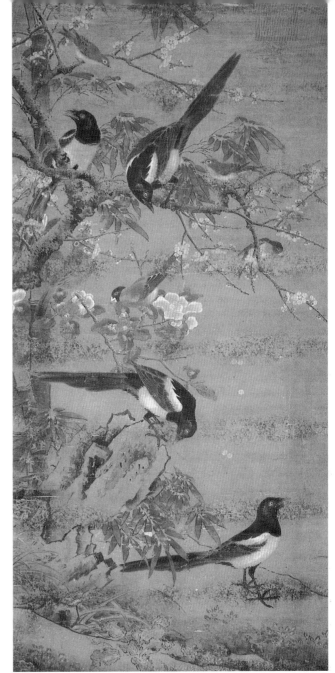

Above: Four magpies—the Chinese symbol of happiness—painted by Zhao Chang captures detail and color in an almost perfect example of the Academic style.

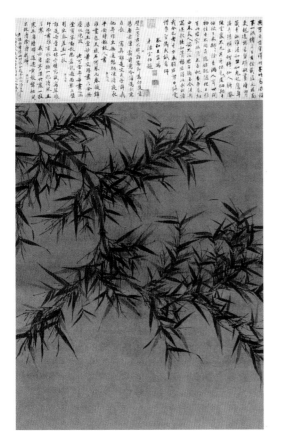

Left: To help explain the flourishing "Literati" style, the great eleventh-century painter, Wen Tong, said, "Before the brush touches the paper, the bamboo is already in your heart."

During the Southern Song period (1127–1271) that followed, the court painters took Academic painting to the highest level of skill and detail. Ma Lin (1195–1264) was one of the leading Academic painters of the period. His broad range of subjects and almost perfect detail was married with a new style of composition that contrasted space with intense areas of detail. His paintings also often included poems whose calligraphy was executed by the emperor or empress themselves.

During the same period, though, paintings by Mu Xi (early thirteenth century) show very different features. Typically, his brush-and-ink work used a minimum of very expressive dark and light strokes, to capture both the vivacity of birds and the gentle simplicity of pine branches and needles. With only a few light strokes Mu Xi created masterpieces of the Freehand style.

Above: A few, very expressive strokes have been used by Mu Xi to emphasize the character of this mynah bird.

Left: Ma Lin (1195–1264) introduced a new style of composition that aimed to capture a subject's beauty by showing it in the simplest form.

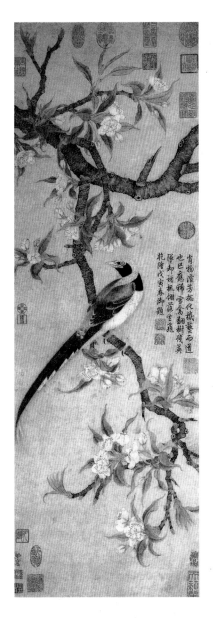

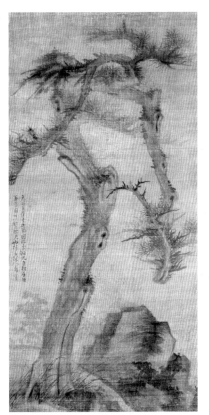

Above: The development of the "Literati" style can be seen in Wu Zhen's study of a Pine Tree.

Left: Academic works like Qian Xuan's Pear Blossom and Pheasant continued to be hugely influential.

Below: This detail of ink plum blossom by Wang Mian indicates the techniques the "Literati" painters retained.

Qian Xuan (1235–1303) was to become the top Academic artist of the Yuan dynasty (1271–1368); however, his working life also straddled the previous dynasty. To develop the Academic style, he ignored the perfection and detail prevalent during the Southern Song and took influence directly from the earlier masters of the Five Dynasties.

Freehand painting developed greatly during the Yuan dynasty. Many intellectuals refused to cooperate with the Mongolian regimé who now ruled China. Being far from the political world, these "Literati" painters immersed themselves in their art, expressing their emotions at the loss of their country to the invaders. Wu Zhen (1280–1354) was a great master of painting, calligraphy, and poetry. His work is a powerful combination of the three arts, and he is now regarded as one of the four great masters of the Yuan dynasty.

Another, Wang Mian (1287–1359), was a poet as well as a painter—most famed for ink plum blossom—who showed great sympathy for the people, describing their suffering and turbulent lives through his art.

During the Ming dynasty (1368–1644) the power of the Academic style declined and was replaced by the "Literati" style in both importance and popularity. However, Lu Ji (1477–?) was a great Academic artist who did his best to save the traditions of the style. The prominence of his paintings in the royal palace ensured his style continued to influence Academic painters for many centuries. He combined birds and flowers with landscapes, using bright but very sophisticated color in his birds to contrast with the pure ink of his landscapes.

Lin Liang (1416–1480), another important Academic painter, was more expressive and free in his brushwork. His use of color was also very simple, painting birds and landscapes using only the tones of water and ink.

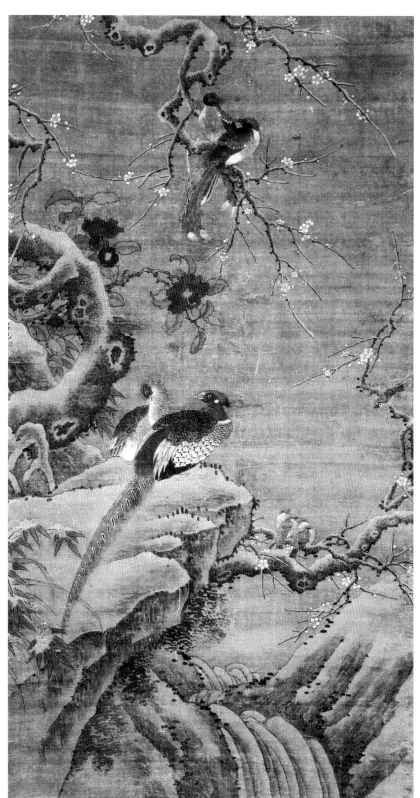

Above: The Academic painters began to lose influence during the Ming dynasty, though some, like Lu Ji, retained prominence through royal patronage.

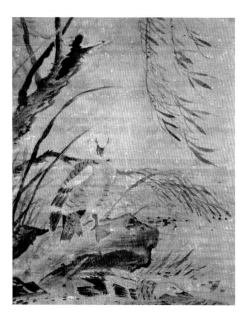

Left: Some Academic works, like Lin Jiang's Duck with Willow, show how the "Literati" painters were now influencing the Academic masters.

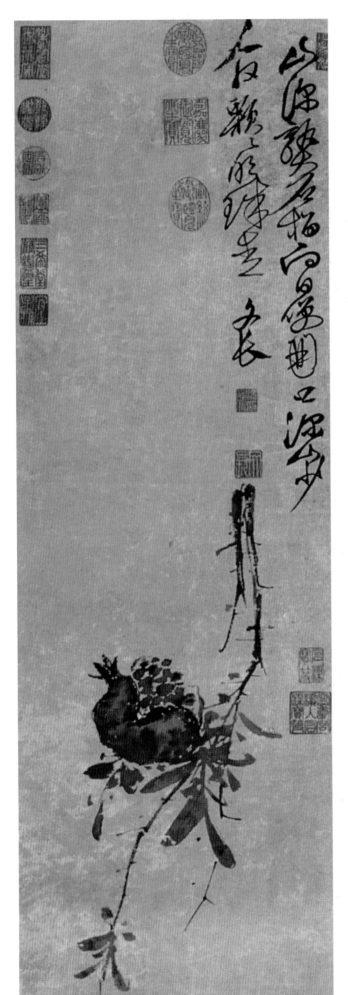

One of the geniuses of Chinese art history, Xu Wei (1521–1593), was a painter as well as a master of literature, becoming famed as the creator of splashed-ink Freehand flower-and-bird painting. His second great innovation, the incorporation of running-script calligraphy into his paintings, allowed him to express all his emotions through his brush and ink.

Since the Yuan dynasty, many artists have come to combine the Academic and "Literati" styles, making it difficult to separate artists into two simple categories. Chen Hong Shoe (1598–1652) was typical of this, collecting different types of art and becoming widely knowledgeable. He also had the finest brush-and-ink techniques and combined painting, poetry, and calligraphy to create his own individual style, becoming renowned as a figure painter. He was also famed for his images of birds and flowers.

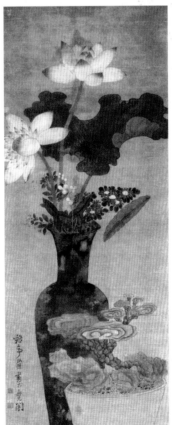

Left: The amazing brush-and-ink techniques of Chen Hong Shoe can be seen in his image of the symbol of peace and fortune—a lotus in a pot.

Far left: The creator of splashed-ink Freehand painting, Xu Wei's Pomegranate also incorporates the running-script calligraphy he innovated.

The 300 years of the Ching Dynasty (1644–1911) were dominated by a series of brush-and-ink "Literati" painters. Many great artists developed, creating very different schools in which many were linked closely to poetry and philosophy.

Zhu Da, also known as Ba Da Shan Ren (1626–1705), was the most influential artist of the early Ching dynasty. A descendant of the Ming royal house, he fled to become a Buddhist monk to avoid being murdered when the dynasty collapsed. The greatest "Literati" painter of his day, he used simple and minimal brush strokes, exaggerating his subjects with the strength of his own feelings of pain for the loss of his country.

Zheng Xie (1693–1765) was one of the "Eight Eccentrics" of Yang Zhou, famed because they developed the Freehand style further from the orthodoxy of the Academy than ever before. He also created his own style of calligraphy by incorporating parts of many differing styles into his painting. He was renowned for the strains and strength he brought to his pictures, evoked especially clearly when painting orchids and bamboo.

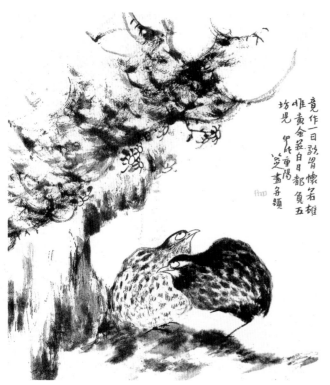

Above: The quail by Ching dynasty master Zhu Da was painted after his exile to a Buddhist monastery to escape murder.

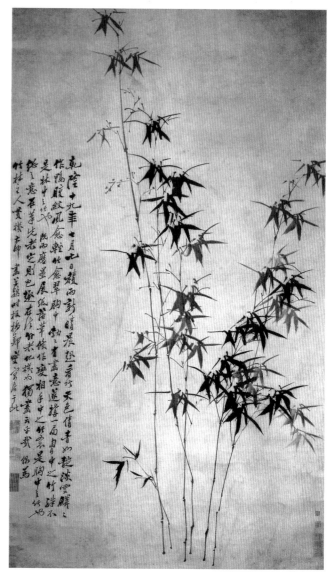

Right: One of the "Eight Eccentrics," Zheng Xie brought immense strength to his bamboo paintings.

During the latter years of the Ching dynasty the extremely creative Shanghai School made a huge contribution to modern Chinese art, developing a strong link between the ancient and modern periods and styles.

Ren Bo Nian (1840–1895) was one of the Shanghai School's leading artists with his combination of both the Academic and "Literati" styles with folk art. He combined the nation's popular and intellectual cultures to give brush-and-ink work a new fresh vitality, exemplified in the bright yet very subtle colors that highlighted his new interpretation of flower painting.

Wu Chang Shuo (1844–1927) was the second great artist of the Shanghai School. One of the greatest painters to combine art and literature, his painting usually incorporated *Zhuan* script, which mirrored the cursive script stroke in his painting. The powerful brush work and rich ink used to paint the heavy, strong forms influences artists even today.

Right: Wu Chang Shuo combined Zhuan script with his very loose style.

Far right: Leading artist of the Shanghai School, Ren Bo Nian combined the Academic and "Literati" styles as never before.

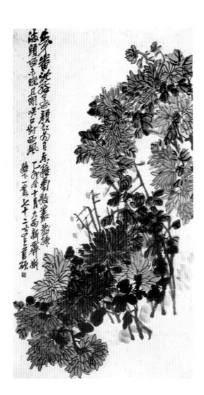

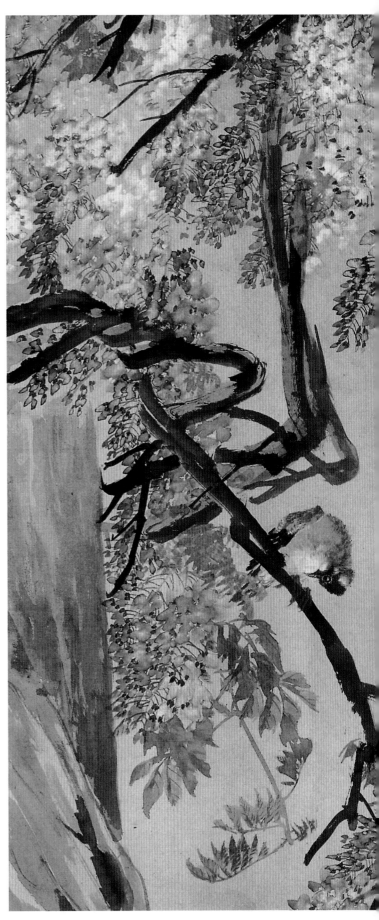

materials

The "scholar objects," or materials, of Chinese painting: ink, brush, ink stone, and paper have been known in China for thousands of years as The Four Treasures. The illustrious title hints at their importance in the history and culture of brush painting, with celebrated artists developing a ritual of laying out the materials in set positions and using the preparation as a time to meditate on the artwork to come. Each of the four pieces has been developed through the centuries. Natural pigments are still used for many of the subtle ink colors.

brushes

The brush is revered as the First Treasure, the extension of the artist's heart through which he is able to express all his concepts and skill.

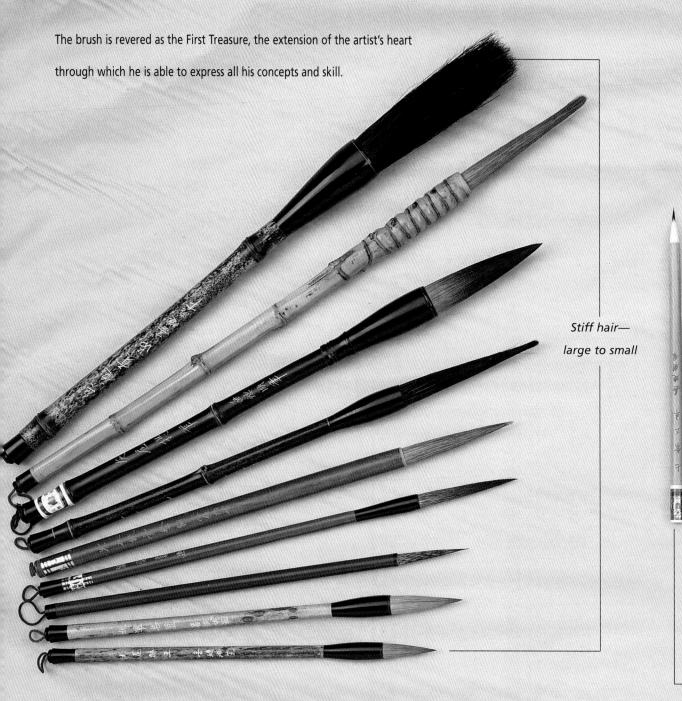

Stiff hair—large to small

Mixed hair

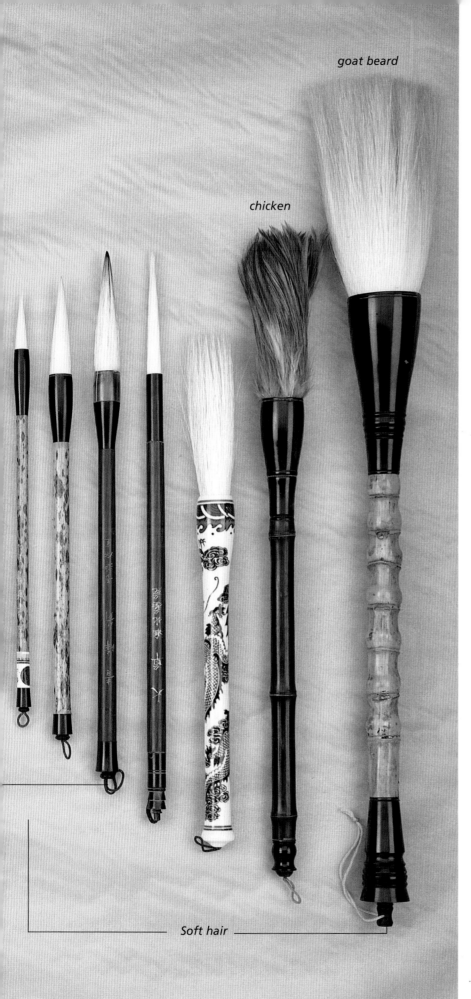

goat beard

chicken

Soft hair

Originally produced from natural hair, brushes soon developed in size and material so that, from the Tang dynasty, many of the qualities and varieties we know today had become available.

The vast number of brushes available is broken down by the characteristics of their hair: stiff, soft, and mixed. Each is found in every combination of size, shape, and length of tip, so there is a brush for every purpose.

Brush Types

Also known as wolf-hair brushes, stiff-hair brushes are now made from horse hair, rabbit hair, or manmade fibers. Use stiff-hair brushes for precision in Meticulous painting and when you first start to learn brush painting techniques.

Mixed-hair brushes, such as "white-cloud" or "green peak," have the advantages of both types and can be used in almost any brush painting style. Remember, though, never to use too small a brush—a large one can be used to paint any size of picture but a small one should never be used when producing a large image. The mixed brushes shown here also contain a selection of more fluid brushes which can also be used as soft brushes.

Soft-hair brushes, made from goat hair or manmade fibers, are more useful when painting in a Freehand style. A more experienced artist can use them to create a vast range of effects.

Choosing a Brush

When choosing a brush, take into account the type of painting, its size, how much control you want to have over the brush head, as well as the four vital components for a brush painter. When loaded with ink the sharpness (*jian*) of hairs, or bristles, should always be well defined, the brush tapering to a symmetrical tip. Equally important is the evenness (*qi*) of the hairs when the brush is dry—they should be level, tapering to exactly the same length. When in use the brush should keep its roundness (*yuan*) and resilience (*jian*) so that it retains its original shape whichever way it is pressed onto paper.

ink sticks and paint

Following the brush, ink is the second of the four great treasures of the artist—without it no picture could be created.

It has taken on a symbolic as well as practical importance, which means that collecting ink sticks has become almost as

important a part of being a brush painter as creating the final artworks.

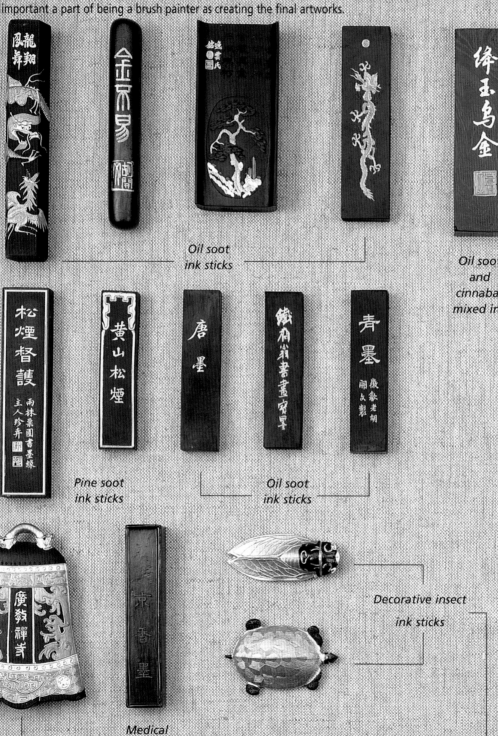

*Oil soot
ink sticks*

*Oil soot
and
cinnabar
mixed ink*

*Pine soot
ink sticks*

*Oil soot
ink sticks*

*Set of calligraphy
backed ink sticks
(c.1800–1850)*

*Decorative insect
ink sticks*

*Medical
ink stick*

Decorative ink sticks

*"Picture"
ink sticks*

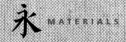

The use of ink can be traced back over 6,000 years. Its quality has developed continuously since the Tang dynasty, increasing the symbolic and artistic importance of ink. Almost all ink sticks are decorated, and some are works of art in their own right. Even those shaped as insects or bells are completely practical and are especially prized by artists.

Modern production methods now allow very good inks to be purchased in ready-to-use tubes, and these are often the best option for a budding brush painter since they have all the qualities of ink ground by hand from sticks with none of the hassle. Remember, though, to let the preparation of the ink be a contemplative time in which to prepare yourself for the painting to come.

Ink Sticks

Traditional ink sticks are mixtures of soot and glue, prepared with preservative and fragrance as well as any number of additional, exotic materials from gold to snake bile. The type of soot and quantity of glue used determines both the color intensity and the usability of the ink. The three main types used are oil soot, pine soot, and charcoal soot.

Oil soot creates the blackest of inks, giving a warm rich color. It is ideal for general use.

If a colder, bluer color is required, ink prepared from pine soot is ideal. It also has less glue and is ideal for painting in the Meticulous style.

When painting in a Freehand style, charcoal ink is often the most suitable as it contains the least amounts of both soot and glue, allowing it to spread easily.

Colored Ink Sticks

Traditional colored ink sticks are made in exactly the same way as black ink, except that instead of soot glue is mixed with natural pigments. Ready-prepared tubed inks are a simple and easy to use alternative.

Other Colors

Alternatively, you can make your own inks by mixing ground pigment—either ready bought or ground from pigment chips by hand—with pigment glue. Other materials are also sometimes useful. For example, tea leaves are ideal for making up brown shades.

Ready-to-use tubed pigments

Pigment

Pigment glue

Pigment chips

Cinnabar ink stick

Tea-colored ink stick

Colored ink sticks

Tea

paper

Known in China as the "profound friend of the artist," paper has developed greatly since it replaced bamboo and wood over 2,000 years ago. Made from exotic woods and barks, it is decorated with materials including the finest gold leaf. As well as there being myriad types and sizes of paper, each is also available in distinct finishes that affect the way ink adheres to it, allowing for the huge diversity in Chinese painting styles.

Grass paper (Mao Bian)

Grass paper (Mao Bian)

Mulberry bark

Sized mica

Unsized, gold-fleck Xuan

Antique brown Xuan

Xuan white

Folded fan paper

Sized antique silk

Bamboo paper (Yuan Shu)

Artist's album

Gold-flecked printed, couplet paper

Types

The most common type is Xuan paper, often incorrectly described as rice paper. Also well used are Mao Bian, which although called grass paper is actually made of bamboo, straw, bark, and bamboo paper. Each should be chosen according to the background required.

All are available in three finishes: unsized, or untreated (*sheng xuan*), the most absorbent; semi-sized (*ban shu*); and sized (*shu xuan*), which has the least absorbency. Always use sized paper when working in the Meticulous style, which requires extremely delicate ink work, but use the absorbency of unsized paper when creating Freehand paintings.

As well as using plain paper, Chinese artists have used many different surfaces for their paintings. The oldest surviving painting, dating from c.600BC was produced on silk, which has remained popular through all dynasties. Before use, though, ensure that the silk has been sized so that it will hold ink. In theory, any surface that can absorb ink is usable, whether paper, silk, wood, or bamboo.

When buying or collecting paper, also remember that unsized paper becomes easier to use with age as the fibers loosen. Conversely, it is best to use sized paper soon after purchase as the treatment given to it quickly begins to be lost.

Dimensions

Chinese painting paper is available in many different sizes and thicknesses. Although never available in exactly matching sizes, paper has traditionally been produced most commonly at the ratio of 1:2 and in sheets from approximately 2 x 4 ft (60 x 120 cm) through to 6 x 12 ft (1.8 x 3.6 m). Square sheets are now becoming more popular while scrolls, whether for hanging or hand rolling—which may be anything up to 150 ft (45 m) long— have always been a traditional format.

ink stones and containers

Modern, bell-shaped She stone

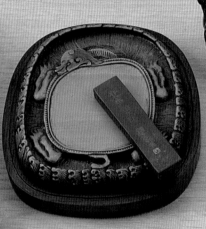

Modern, Manchurian, sea tortoise, Song Hua ink stone

Water dropper

Ink case

Color-mixing trays

Dragon design brush rest

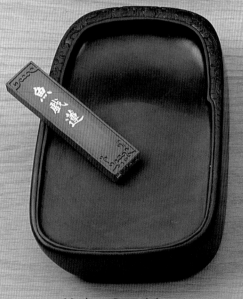

Modern, Duan ink stone

c.1700–50, Cheng Ni ink grinder

Ink stick

An ink stone is a vital part of an artist's equipment and may be treasured through an artist's entire life. Some may collect hundreds, which will be treasured because of their own qualities. Some will be *ming yan*—antique stones that once belonged to famous people or great artists—and of varying quality. Others may be *gu yan*—old stones that are anything up to 2,000 years old—or *jia yan*—stones of exceptional quality with intricate decoration that may be of any age.

Tripartite brush-washing dish

*Ink dish
with ready-
mixed liquid
pigment*

Paint holder

Your Ink Stone

When choosing your own ink stone, there are a few important factors to take into account. Most important is the quality of the stone, its *zhi*. The stone's surface must be smooth enough to produce consistent ink quickly. The best shape (*pin*) is a regular rectangle, square, or circle. The stone must have a solid wooden cover or box to protect the surface and keep any unused ink fresh. The workmanship (*gong*) should show skilful carving, and, ideally, there should be inscriptions (*ming*) recording any important dates, previous owners, or historical events.

Of the many hundreds of types of ink stones produced through China, four of the most famous are the Duan stone from Canton; the She stone of An Hui and Jiang Xi provinces; the Tao stone of Gan Su; and the Cheng Ni, which is made from the mud of the Yellow River. Production of these pottery stones recently resumed after over 200 years, as did the Song Hua stone. During its previous period of manufacture, all examples were produced exclusively for use inside Beijing's Forbidden City.

Other Necessities

Along with an ink stone, you will also need various other pieces of equipment, including:
• Water dropper—a little pot to hold the water that will be used to grind the ink. It must have a delicate spout to allow control over the few drops that are used each time.
• Brush rest—made of brass, iron, ceramic, stone, or hardwood, this brass example (left) resembles a dragon.
• Brush washer—use a tripartite container that holds enough water to last the whole painting session while both cleaning brushes of excess ink and making up color washes.
• Color-mixing trays—have a set of mixing trays ready so that all your washes and colors can be easily made up without the need to clean them while painting your picture. If needed, prepare a separate dish for ready-mixed liquid ink.
• Paint holder—this has compartments for all the colors you will need. Dispense them all beforehand.

preparing the table

Creating the right atmosphere to work in is an important part of the art of brush painting. Your working area should be tidy and contained so that when you start painting nothing diverts your attention from the picture; try not to allow your concentration to be distracted by the practicalities of painting. Spend time placing everything you will need at hand, making sure that you have all the brushes, inks, and seals within easy reach before the first stroke is made. As you prepare the table, let your mind wander over the picture you are about to paint.

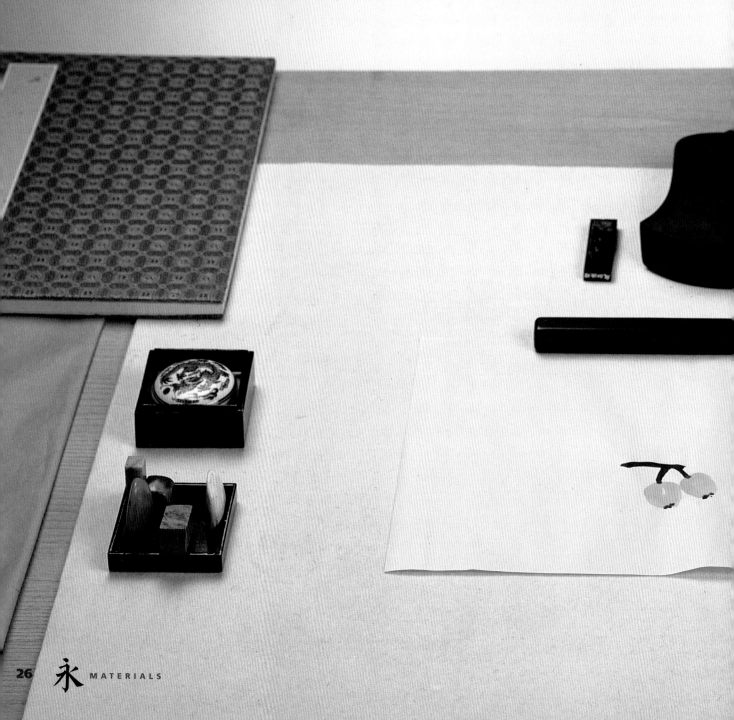

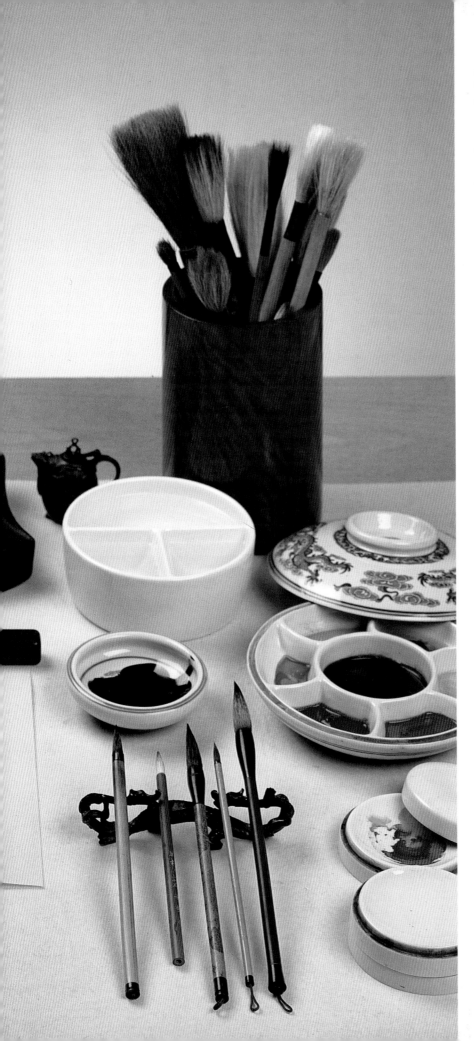

Preparing the Table

When you have decided the size of paper you want to paint on, fix the area needed with a paper weight in front of you. Then place your brush rest with the brushes close at hand on your right-hand side, alongside a set of color-mixing dishes, ensuring that the colored inks to be used and the water container are close enough for you to be able to reach them easily with a brush. Further back, though still within reach, place your ink stone and ink preparation materials. The area directly in front should be left open for your subject matter, with less immediately important items—like your seals and printing paste—within reach on your left.

Preparing the Brush

A few minutes before you start painting, thoroughly wet the bristles of all the brushes you will be using in clean, cold water and leave to rest until you need them.

Preparing the Ink

Generally, the most commonly used colors are black ink, made with traditional ink sticks, and ready-to-use tubed colors. To prepare a quantity of black ink, drop a small amount of water onto the center of the ink stone and lightly grind the stick, held vertically, in a smooth, circular motion until the right consistency is reached. Remember to dry the ink stick immediately; otherwise, the end will become cracked and uneven. Finally, ensure that quantities of all the colored inks you will require are ready in your paint holder, along with enough color-mixing dishes for all the combinations you will be making.

techniques

This chapter explains clearly how to master the techniques and key flower-and-bird subjects of Chinese brush painting in both the Literati, or Freehand, and Meticulous, or Academic, styles. An introductory section covers the basic brush-and-ink skills, showing the correct way to hold the brush and how to mix and vary shades of ink. Essential strokes to practice for a professional result in your own work are then revealed. Diagrams, templates, and step-by-step illustrations show you how to create each of the classic and meaningful Four Gentlemen—the blossom, orchid, bamboo, and chrysanthemum—as well as a range of elegant birds, including the swallow, the Oriental quail, and waterbirds.

Each section describes how to build up your subject, from the initial sketch or drawing from life, through to the placement of individual details such as petals, feathers, or leaves, as well as the correct painting sequence for the whole image. With both the historic Literati and Meticulous approaches covered in full for all the flowers and birds, the final section reveals the secrets, ancient and modern, of elegant composition, explaining how to plot your subject for the best effect and even how and where to place the seal to finish your work.

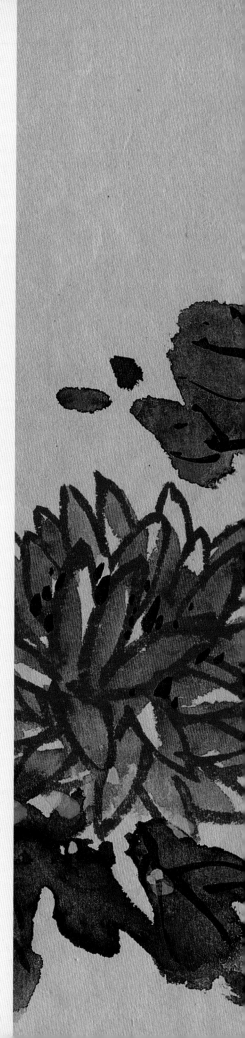

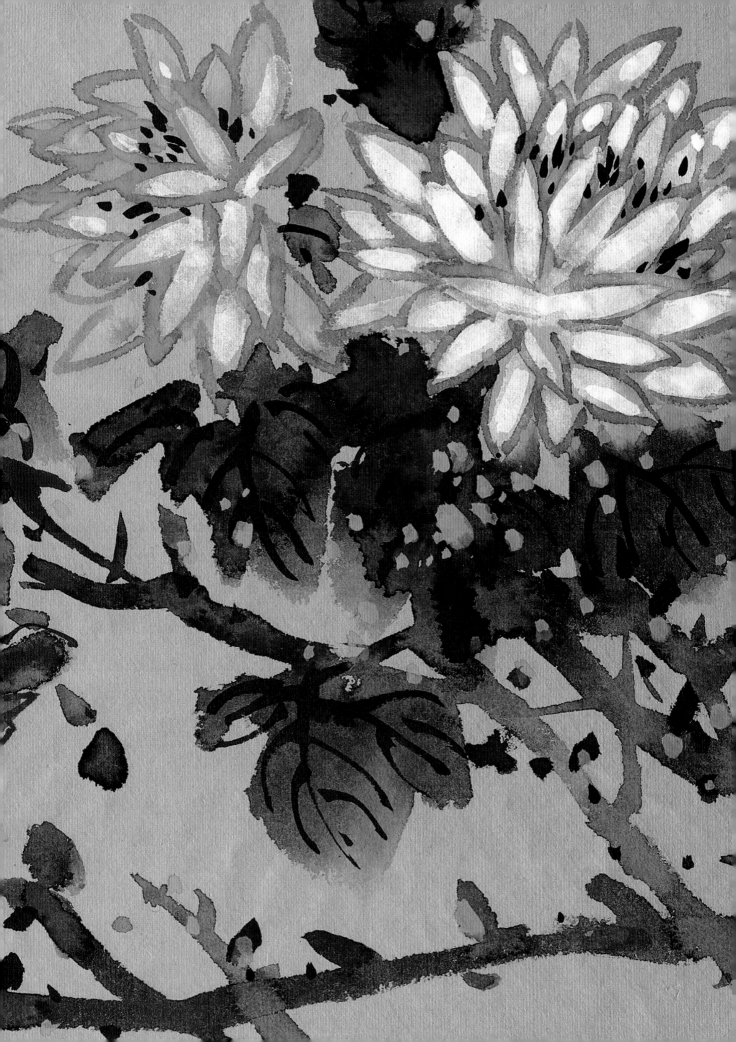

holding the brush

The brush is an extension of your hand that allows you to transfer your thoughts to paper. It must feel comfortable, and, whether large or small, it needs to be held with a firm yet gentle grip that allows full control of the tip while giving complete ease of movement.

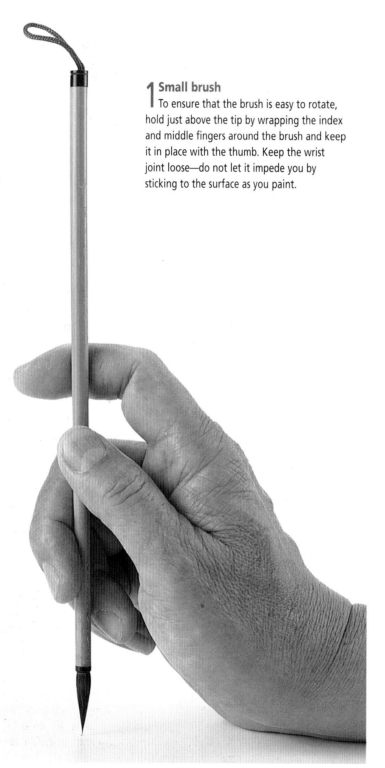

1 Small brush
To ensure that the brush is easy to rotate, hold just above the tip by wrapping the index and middle fingers around the brush and keep it in place with the thumb. Keep the wrist joint loose—do not let it impede you by sticking to the surface as you paint.

2 Large brush
Hold with a straight wrist, half-way up the brush, keeping the index and middle fingers wide apart.

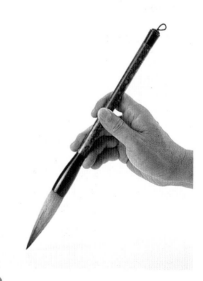

3 Make all small movements by pushing the brush tip with the third and little fingers.

mixing and using ink

The base of all brush painting, black ink, has myriad uses, whether for preparing a first sketch or shading a final piece. Colored inks and pigments are treated in the same way, and a key part of early practice is mixing, and then washing, inks to discover their variety of shades.

Mixing ink with various amounts of water to create washes shows the many effects and tones you can create with inks. The five principal shades are shown here.

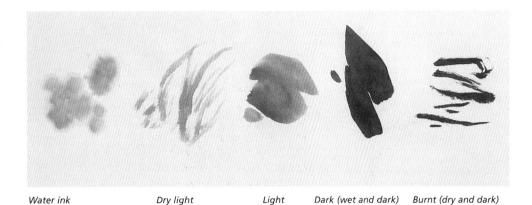

Water ink *Dry light* *Light* *Dark (wet and dark)* *Burnt (dry and dark)*

MIXING INK

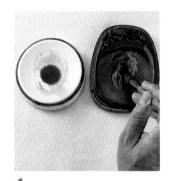

1 Take a little black ink from your ink stone and place it in a mixing bowl.

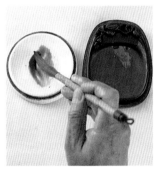

2 To lessen the intensity, add more water to the ink.

3 Load the brush with ink by pressing the whole tip into the mix.

4 To allow color gradation, dip the tip in the dark ink.

USING THE INKWASH

1 Mix a wash, as described above, and use a narrow, red-hair brush to draw in the thin outer edges of the practice subject—here a leaf.

2 Load one white-cloud brush evenly with ink. Using the side-tip stroke (see page 32), place the tip against the inner side of one line and work in, away from the edge.

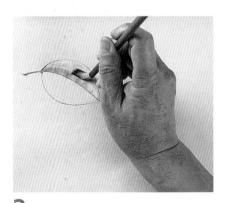

3 Load another white-cloud brush with water and wash the wet ink across the main area of the leaf, grating the color as required.

the strokes

Only a very few strokes are needed to be able to start brush painting. Once you are confident of your grip on the different sizes of brush, practice the dot and the few strokes and begin to paint.

PULL STROKE

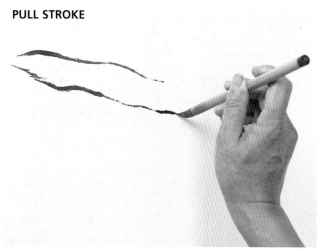

Centered tip — Pull stroke

The most important and most basic stroke, the Pull, allows the most amount of control over the brush tip. Pulling the brush while keeping the tip parallel to the center of the line ensures even ink depth whichever direction the brush moves in. The direction of the brush shaft must replicate the line being drawn for the tip to retain its shape, so hold the shaft upright and pull the tip around gently when changing direction.

PUSH STROKE

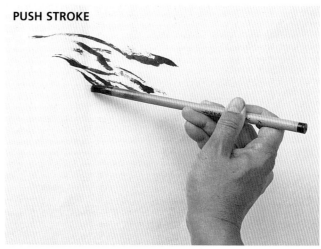

Centered tip — Push stroke

To vary the texture created, the brush can be pushed forward as well as pulled. Even though the tip is now bent back underneath the shaft of the brush, it must still remain constantly in the center of the line, so push the brush along the line you intend to paint in shorter movements. Changing the angle at which the brush shaft is held changes the texture of the line—the key is letting the brush move in any direction as long as the tip remains in the center.

SHORT PULL STROKE

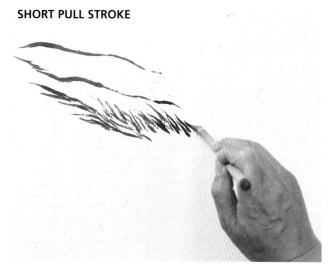

Centered tip — Short pull stroke

This uses the same technique as the basic pull stroke but is extremely useful for drawing leaves, sharp petals, and grasses. Lifting the brush away quickly adds a sharpness to an otherwise even stroke.

SIDE TIP STROKE

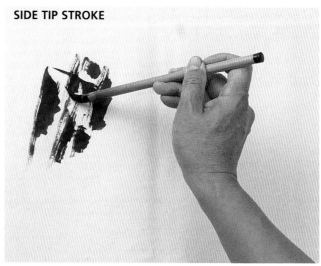

Side tip

To make a broader mark use the largest part of the brush, the side of the tip. So that the tip always travels in the same direction, the brush must be held at right angles to the stroke. This stroke is much less common. Only use it to create certain special effects—for texture on tree or bark or some types of rock.

THE DOT

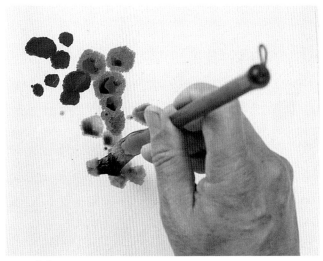

Round dot
To create a clear, circular dot, hold the brush absolutely vertical, press the tip down onto the paper, and lift in one fluid movement. Practice in the Freehand style before using the same technique with a smaller, stiffer brush in Academic-style paintings.

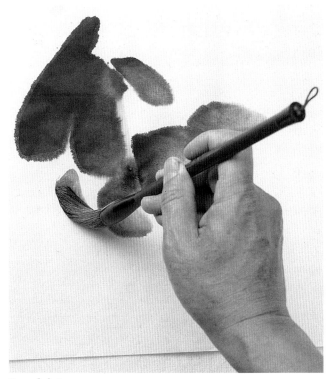

Broad dot
Ideal for leaves or petals, this is a free stroke that can turn and go sideways during the brush stroke. As for the round dot, drop the brush straight down onto the paper, but this time move the brush as you turn it before lifting it away from the paper. The same stroke in different thicknesses and lengths can be used for all leaves. Use a medium brush for the long, thin leaves of the peony, a narrow brush for the even more elongated peach leaves, or a large, soft brush for short and wide chrysanthemum leaves.

USING STROKES TO CREATE CONTRAST

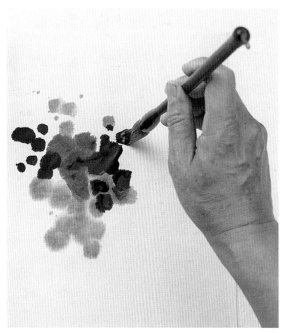

Combining colors
Create contrast by applying different color shades using the same technique, applying identical pressing. Only a very few techniques are needed before you will be able to create strong images.

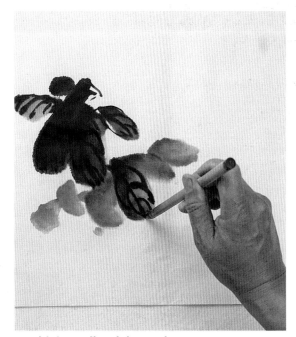

Combining pull and dot strokes
Crisp contrast can also be achieved by juxtaposing dot and centered tip strokes. Here, veins are added onto the leaves that were painted in a broad dot stroke with a smaller, stiffer brush in a centered tip stroke.

plum blossom

When painting plum blossom, always start with the branches. Then add the flowers before completing the piece with the stamens, calyxes, and branch texture. Throughout, where numbered, the illustrations of techniques refer to the corresponding steps.

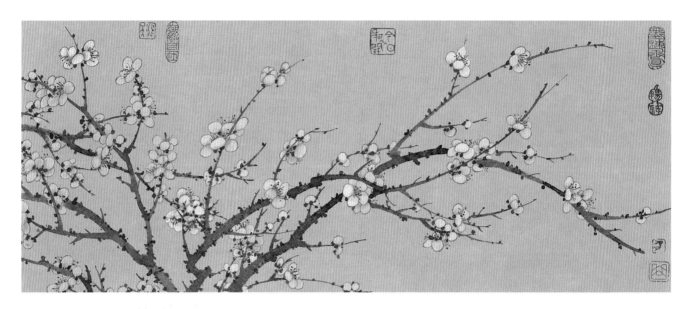

LITERATI BLOSSOM

THE BRANCHES

Use a combination of heavy, woody branches with smaller, snappy, sprouting branches to form the general structure of the painting.

1 Although the brushes you choose depend on the size of the painting, use a softer brush for the bigger branches and a smaller, stiffer brush for long and sinuous new branches.

2 Use a Pull stroke (see page 32), remembering to keep it positive, confident, and fluent.

3 Divide the branches like a deer antler. Where the branches separate, emphasize the join by pressing the brush into the painted branch, as shown, leaving a strong dot of ink before flicking the brush away to a point.

4 Avoid joining three branches at the same point and leave space in front of the branches to insert flowers.

5 When branches cross, they should form diamond patterns. Never paint branches that cross at 90 degrees or that are parallel to one another; use the template as shown below.

6 As you work, check the brush. The ink should be neither too dark nor too wet.

7 Generally ensure that younger branches are darker than older ones, except when they appear in the background of the composition.

8 Finally, indicate the texture of the branch by using very dark ink to add dots showing the rough surface of the bark.

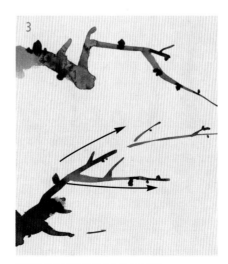

Divide the branch like a deer antler.

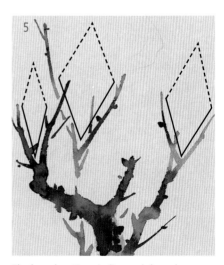

The branch pattern is diamond-shaped.

BLOSSOM

There are two ways to paint the blossom—drawn or dotted.

1 Drawing the blossom
The blossom can either be formed from a single layer of petals or be multilayered. Single-layered flowers always have a total of five petals. Use a fine drawing brush—a small red-hair or crabclaw.

2 Draw a petal in two semicircular strokes from the top.

3 The petal should never be perfectly round, always erring on the plump side.

4 Blossoms on one branch should face different directions and be in various stages of blooming. Flowers shown without stamens are still in bud, while those that include stamens but fewer than five petals are near an end.

5 Contrast the density of blossoms through the picture—blossoms do not bloom evenly everywhere.

6 Where branches cross each other, there are areas with more flowers.

7 Plum blossoms bloom in stages from the center of the plant towards its extremities. Never show flowers in blossom at the tips of branches with buds lower down.

8 Whatever the color, the ink of the blossom should be more diluted than the branch on which it sits.

9 Paint in the stamens with dark ink. Use the tip of the brush to give the fine lines accuracy and strength, making so-called "tiger whiskers." Complete with round pollen dots.

10 The calyxes are only visible when the blossom is seen from the back or is in bud. Use dark ink dots when required.

1 Color dot blossom
Use a dot of ink or color. The colors should be white, pink, red, yellow, or green.

2 Ensure that the brush is always holding a lot of color and ink; never let it dry out.

3 Paint the closest blossoms with the strongest color, becoming gradually weaker towards the background.

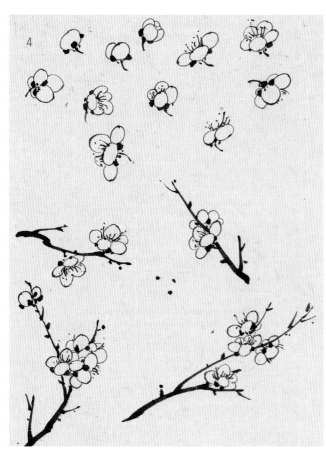

A variety of blossom in bud (top) and bloom (bottom).

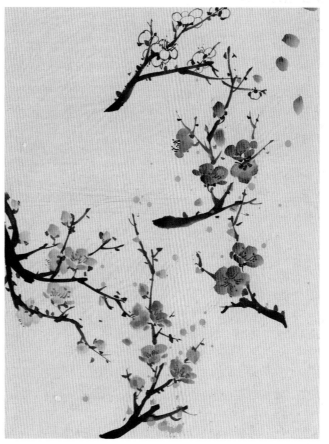

Drawn (top) and dotted blossom (bottom).

1 Either sketch your branch or photocopy the illustration opposite and use it as a template. Draw the ink lines with positive and strong strokes before placing the younger branch using single strokes with a white-cloud brush. Finally, use darker ink to add the calyx dot.

2 Begin to add color by ink washing the branch with two small white-cloud brushes. To emphasize the more hollow areas of the branch, use one to place the ink and the other to wash over and spread the color. Add a pale burnt siena wash over the petals. Use one brush with ink to place the ink at the center of the petal, and fill the second with water to wash the ink outward, towards the edge of the petal.

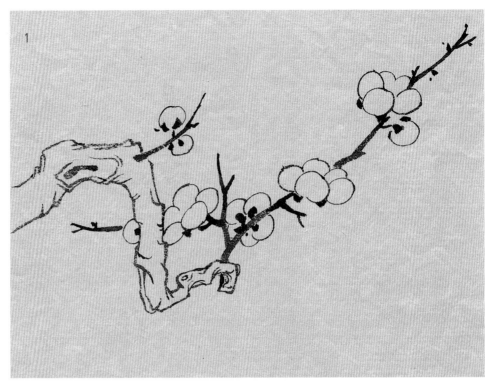

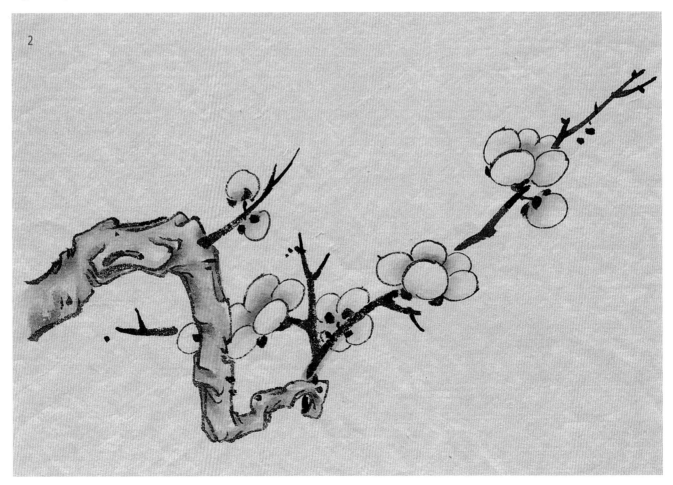

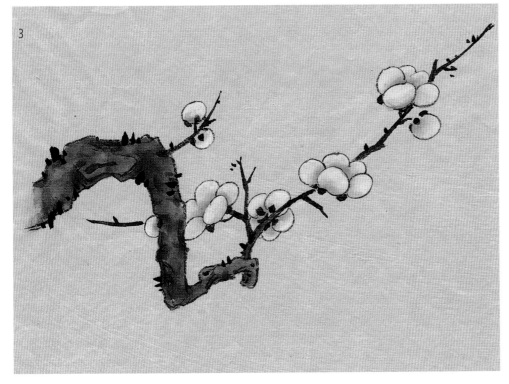

3 Colorwash the branch with a mix of indigo and burnt siena. When the petal is dry, whitewash the petal from the outside inward so the two washes merge. When the wash on the branch is dry, place dark ink dots on the branch.

4 Add stamens with a white fine line and the pollen dots in a mixture of white and yellow. Finish by adding texture to the branch with a mineral green dot—also called the "precious stone."

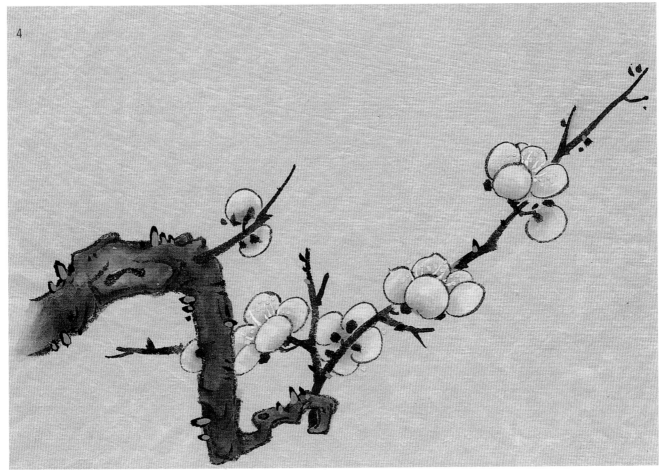

orchid

Although there are many different types of orchids, learning the techniques needed to paint just one of the hundreds of species will give a basis for all the others. The key for orchid painting is tranquility: peacefulness, elegance, and serenity.

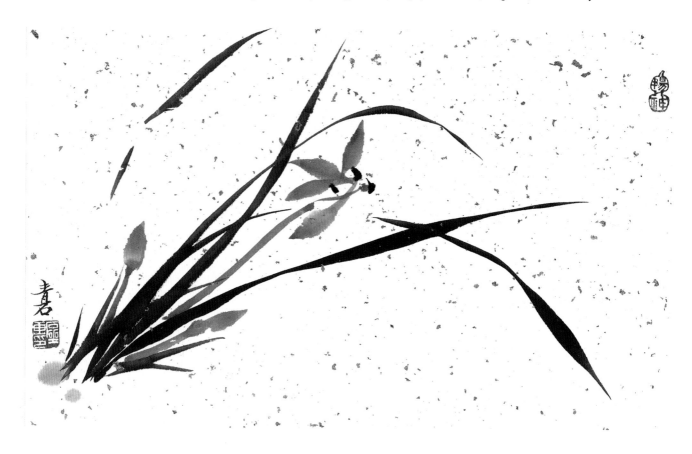

LITERATI ORCHID

LEAVES

1 Use a great orchid bamboo brush.

2 Generally, use dark ink though leaves in the background and supporting groups can be lighter. If you prefer to use a color to draw the leaf, mix indigo and yellow to make a green.

3 As an orchid leaf is long, thin, and very mobile, its front and back should be seen in every brushstroke. Start each stroke with the brush pressed down firmly before lifting it slightly at the bend. Rotate while still moving forward and, pressing down again, move off in a new direction before lifting away from the paper at the point of the leaf.

4 Leaves need to be arranged using the following basic structure: the first stroke is the New Moon (1); the second crossing stroke is the Phoenix Eye (2); the third breaks the Phoenix Eye (3); and the fourth and fifth are the supporting strokes (4 & 5). Following this method allows hundreds of leaves to be arranged successfully.

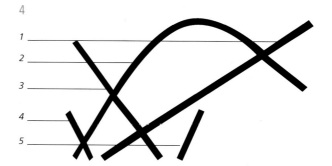

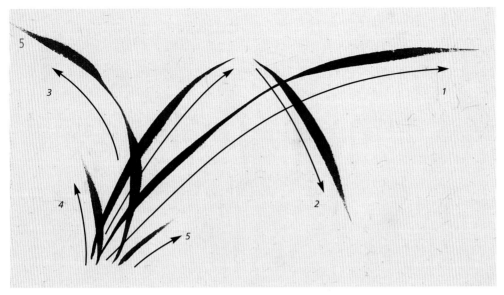

5 Although leaves can be long or short, or fat or thin, they should always be arranged in this basic five-leaf structure. Follow the stroke diagram for each leaf.

6 The leaf can be growing upward, downward, leftward or rightward.

7 The leaf can be seen from the front or in profile, densely clustered or loose, dark, or light.

Above: The key to the elegance of orchid painting is the five-leaf structure (5).

Right and Below: The delicacy of the orchid contrasts well with a harder, study surface, but the five-leaf structure allows the positioning of the orchid to be unusual, yet still flowing and natural.

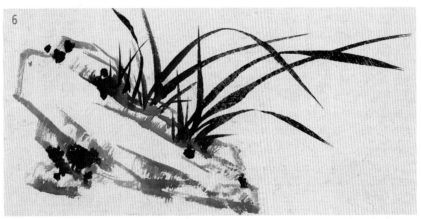

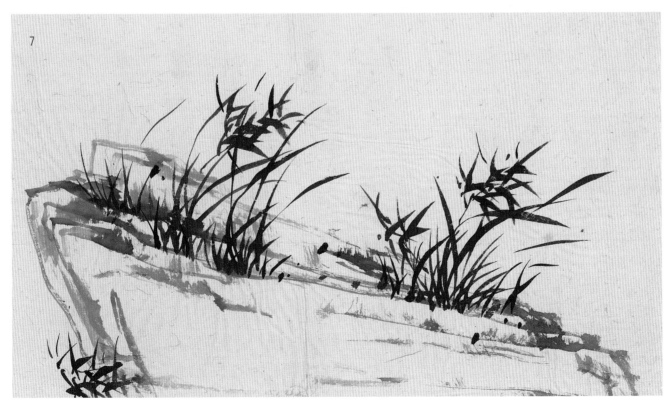

FLOWERS

1 Use a mixed-hair brush and light ink.

2 Fully bloomed orchids have five petals. If you look at your hand with your thumb and middle-finger tip touching, the shape made closely resembles an orchid. With a stroke for each petal, the first two strokes for the central two petals are usually very close together. The third stroke should be smaller and just touch the first pair at the back. The fourth and fifth strokes are more open, one on each side.

3 It is important for the brushstrokes to be made from the tip of the petal inward. Start with the brush pressed down and move toward the flower base, gradually lifting the tip of the brush up.

4 The flowers should bloom in all different directions and show both buds and fully blooming flowers.

5 Dark ink dots show the stamens, usually three for each flower. To make the dot, allow the brush to spring quickly away from the paper, hardly touching it before it is pulled away. In certain places, the stamens can clash with or overlie the petals.

6 The stalk should follow the leaves. Each stalk should have a flower.

7 One special species is the multiflowered orchid. The leaf is the same, but many flowers grow from one stalk, each joined by a small stem. You may paint either single or multiflowered orchids, but they should never be combined in one picture.

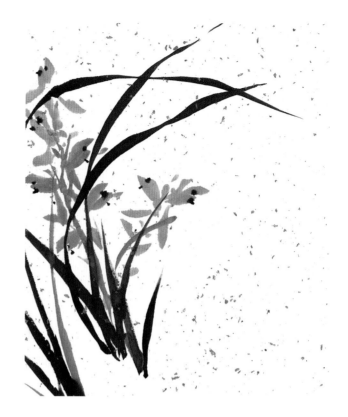

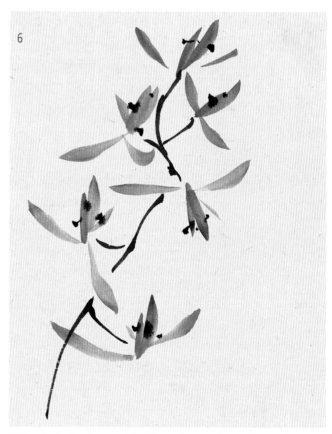

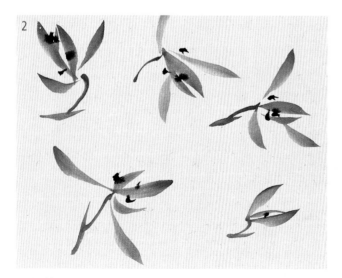

Orchid flowers should have five petals; use a stroke for each petal.

Follow the leaf pattern, not the bloom, for a perfect stalk.

METICULOUS ORCHID

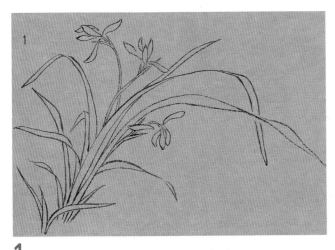

TIP

Focus the weight of the composition to one side of the picture. Ensure that the subject is never placed in the center; likewise, do not place leaves symmetrically.

1 Either draw the outline of the orchid or trace from a template, using a fine red-hair or crabclaw brush and black ink.

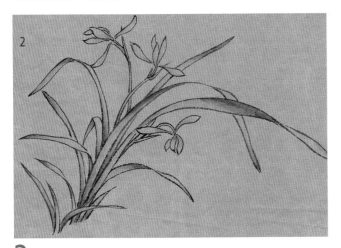

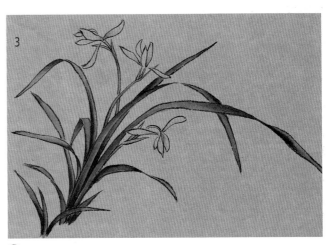

2 Using a small white-cloud brush, wash the leaves in ink. Wash the petals in indigo, working from the inside toward the edge.

3 Mix indigo with yellow to colorwash the leaves.

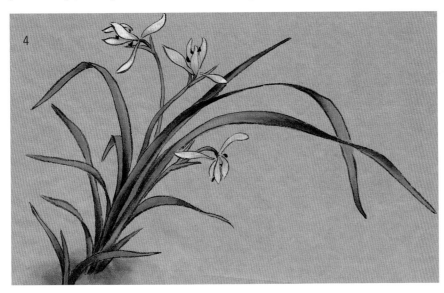

4 Wash the petals in white from tip to center before dotting the stamens in a dark purple made from ink mixed with crimson. Finally, highlight the leaves in mineral green.

bamboo

Traditionally, the bamboo is divided into four sections: the pole, the joints of the pole, the branches, and the leaves, and should be painted each in this order. For maximum "chi" or spirit in your work, use single, flowing strokes as you work through each section.

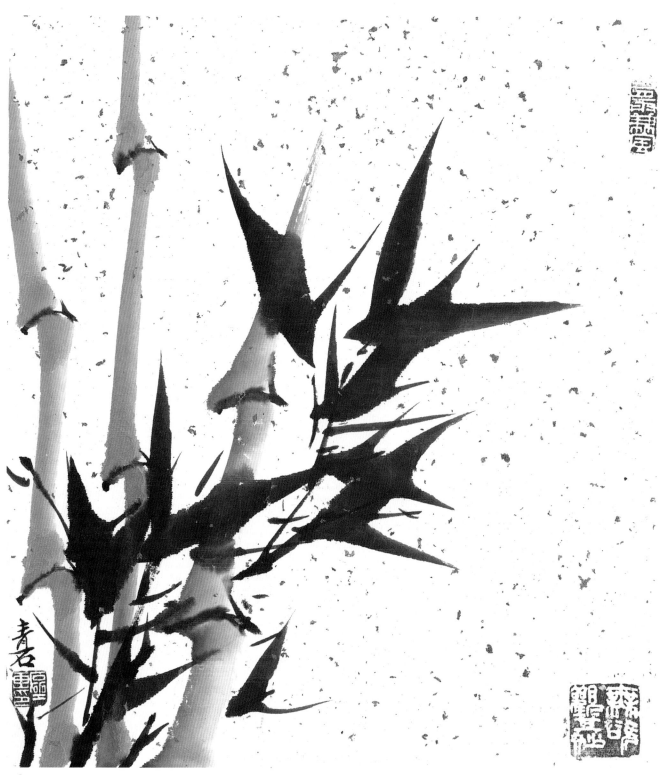

LITERATI BAMBOO

THE POLE

Use a soft or mixed-hair brush.

1 Prepare the brush with light ink. Then dip the tip in darker ink and press the brush on the palette to create a smooth gradation of color from darkest at the tip to light. Before you start, decide on the height of the pole and how many sections it will have. Also ensure the brush has enough ink to paint the entire pole. Never reload the brush after starting to paint a pole.

2 Start at the bottom of a pole. Holding the brush vertically, work through the stroke diagram below. Press down on the paper. Immediately rotate the brush half a turn counterclockwise and slightly lift the brush. At the same time, move upward to the end of the first section. Stop briefly and lift the brush tip up leftward. Meanwhile, rotate the brush back half a turn clockwise. Leave a little space between sections for the joint but immediately continue the next stroke and keep moving up the pole. When the brush is moving, the tip should be in the center of the stroke.

3 The sections on every piece of bamboo pole should become longer toward the center of the pole, before shortening again toward the top.

4 If there are more than two poles in one picture, their joints must be painted at different heights and the poles must be of slightly different thickness. The color of the ink should also differ between poles and they should never be parallel. If two poles cross do not cross at the joint. Finally, do not cross three strokes in one spot.

5 Don't draw too many poles in one picture and vary the thickness of the poles.

6 Plan the pole before you pick up the brush. As soon as the brush touches the paper, you should know exactly where the pole will end.

THE JOINT

Use a fine-tipped, stiff brush and dark ink.

1 Fit the joint in the gap left between the sections of the pole. Start the brush at the bottom left corner of the upper section. Press down to the left, lift the brush slightly, and move it in a curve to the right through the gap. At the right-hand end of the joint, press down and then flick the brush up.

2 At the beginning and end of the stroke, the joint should slightly overlap the corners of the pole. Allow the ink of the joint to merge naturally with the sections of the pole through the curve of the stroke.

THE BRANCH

Use a long-tipped, stiff brush and ink that is darker than the pole but slightly lighter than the joint.

1 Paint the branch in the same way as the pole but with a thinner and longer brushstroke. To keep the feeling of resilience, ensure the lines are sharp.

2 Branches grow only from the joint or from the root. If they are on the joints, place them on alternate sides of the pole.

3 The branch can divide into three smaller branches in a "bird's claw."

4 Don't paint so many branches that an overly large number of leaves is needed.

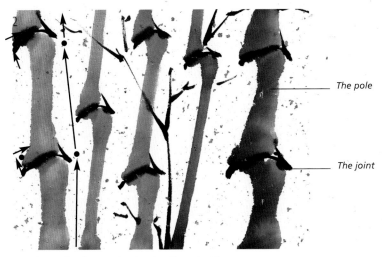

The leaf

The joint

The branch

The pole

Paint your bamboo in this order: pole, joint, branch, and leaf.

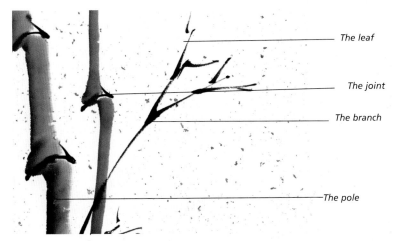

The pole

The joint

Use the stroke diagram for drawing the pole (2).

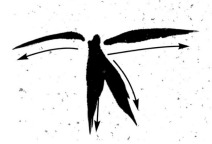

Moored boat (left) and new moon (right) (a)

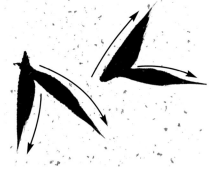

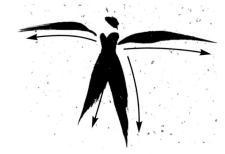

Swallow tail (left) and fish tail (right) (b)

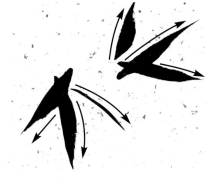

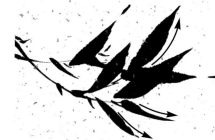

Gold fish tail (c)

Landing geese (d)

Flying swallow (e)

Fish tail combination (f)

THE LEAF

Using a big brush with a sharp tip, either soft or stiff, follow the stroke guides above for leaves (a)–(g).

1 Use dark ink for leaves on the front of the pole. If the leaf is to the rear of the pole use a lighter ink.

2 When the brush touches the paper, press down hard for about one-third of the leaf's length and then, while moving to the tip of the leaf, lift it off the paper at the same time.

3 Leaves can be arranged in a number of groupings. A single leaf seen from the front is called the "moored boat" and in profile the "new moon"(a). A two-stroke group is a "swallow tail" (b), or if more open a "fish tail"(b). A three-stroke group is a "gold fish tail"(c). A four-stroke group is "landing geese" (d). A five-stroke group is a "flying swallow" (e).

4 Many combinations of leaves can be included: (f) is a combination of fish tails in the wind, showing younger leaves; (g) is a combination of flying swallow and landing geese showing mature bamboo in summer.

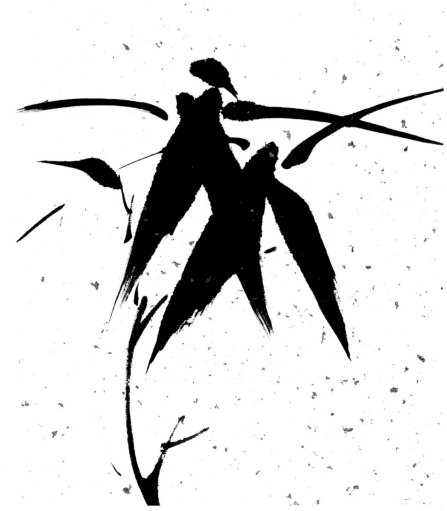

Flying swallow and landing geese leaf combination (g)

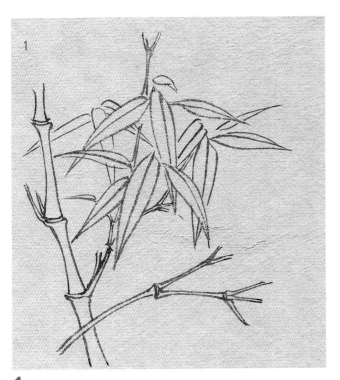

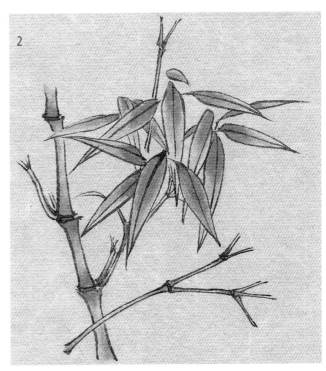

1 Either sketch your bamboo or photocopy the illustration (1) above and, with a red-hair brush, use it as a template to trace off the ink lines.

2 Use two white-cloud brushes for a pale ink wash.

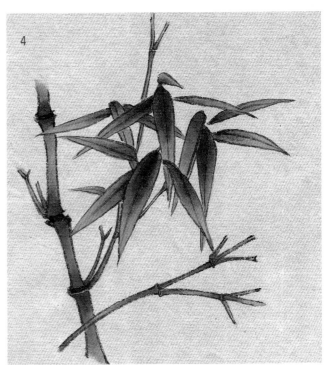

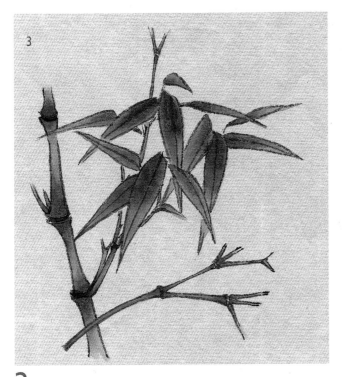

3 Use indigo and yellow to colorwash the pole and leaves. The older branch incorporates a wash of burnt siena.

4 Highlight the leaves with mineral green to finish.

chrysanthemum

Symbolizing the turn of the seasons toward fall, the beautiful chrysanthemum has myriad colors

and species, and the techniques here are suitable for every variety.

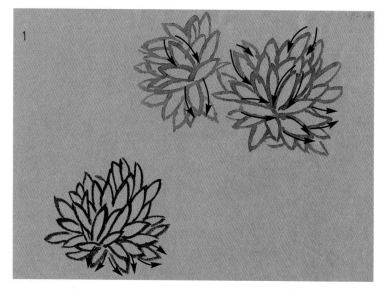

LITERATI CHRYSANTHEMUM

1 First, draw the ink outlines of the petals with a stiff brush held vertically from the top. Following the stroke diagrams, make the lines clear and positive showing petals radiating from the center in all directions. There should be some variety—no flower should be absolutely symmetrical.

2 To infill the color, use a softer brush following the general direction of the petals. Do not be constrained by the outlines of individual petals as long as the overall structure feels right.

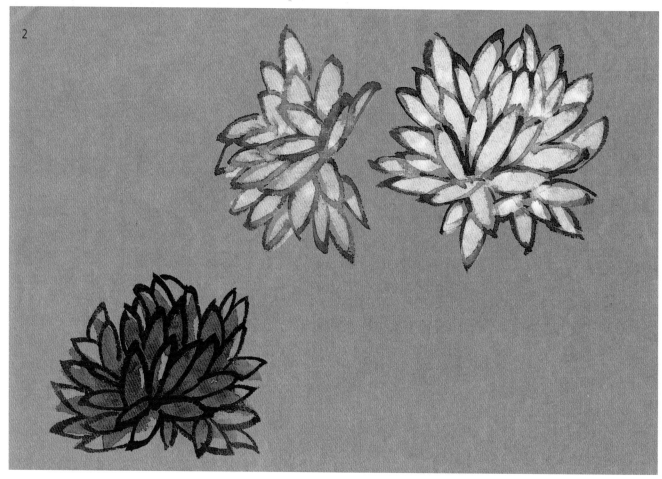

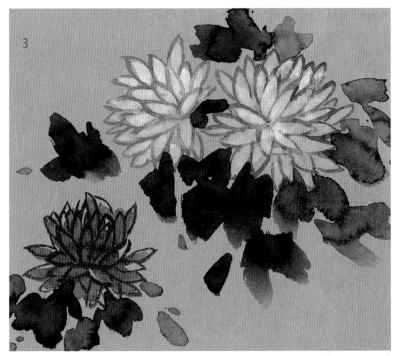

TIP

When painting chrysanthemum the sequence should always be flower first, then leaves, then stalks, and finally the decorative dots.

3 Paint the leaves with a big soft brush. Work in a combination of ink, indigo, and yellow, using more indigo for the darker, forward-facing leaves. Generally, use three strokes to construct each leaf, a single one for each section.

4 Use dark ink to paint the branch, each one relating to the center of a flower. Add texture by including veins on the leaves and dots along the branches in a darker ink. Finally, add mineral green dots to increase the atmosphere.

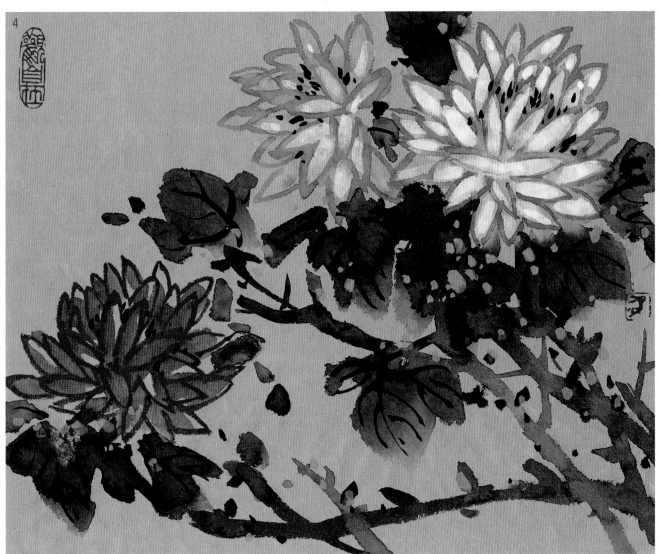

METICULOUS CHRYSANTHEMUM

1 Either sketch your flower or photocopy the illustration below (1) and use it as a template to trace the image onto the paper with a fine brush and ink. If you use a template you can concentrate better on the quality of the line drawing without worrying about composition.

2 Like the loose strings of a musical instrument, the lines of the flower should curve fluently, ideally showing how the petals relate to each other.

3 For the leaf and the stalk, start with the brush pressed down, but as soon as the stroke begins lift away from the paper creating a tapering line.

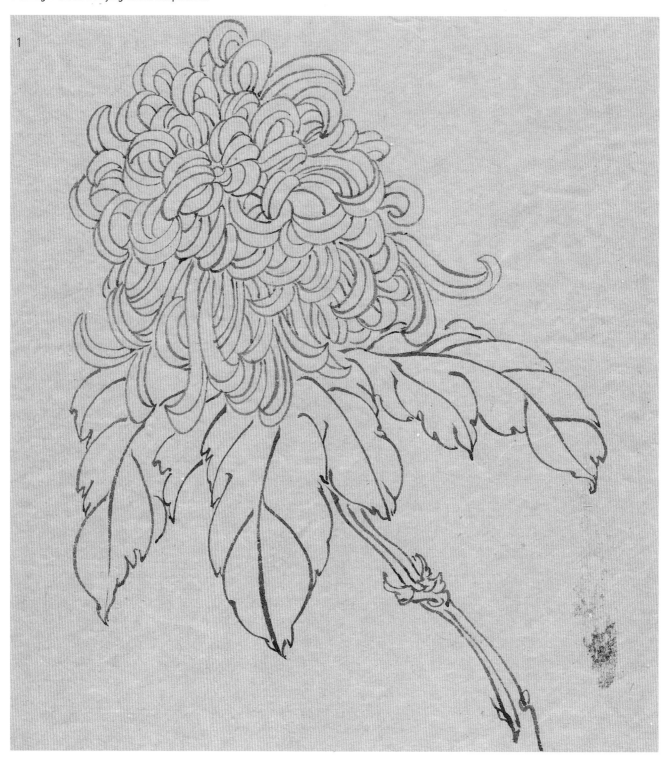

1

8

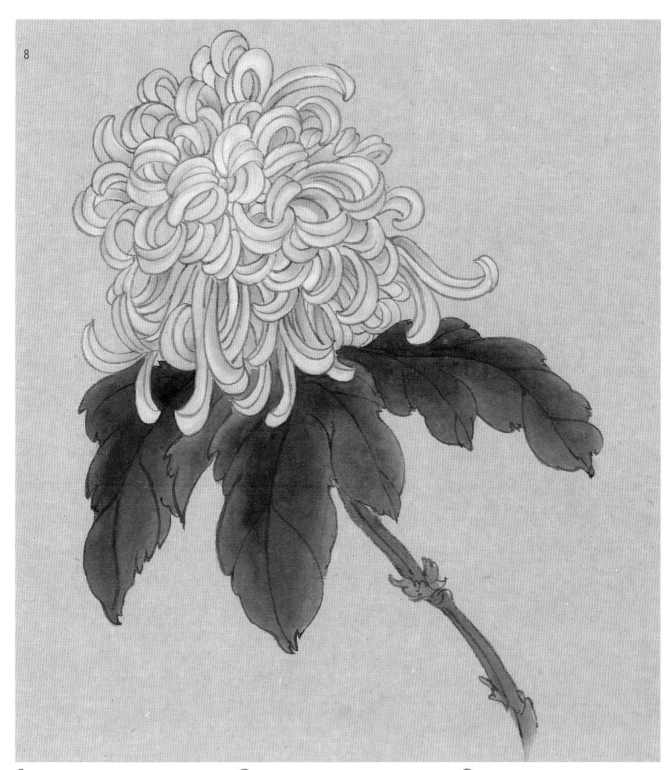

4 Use a very light ink wash on the base of each petal and along the main veins of the leaves.

5 Highlight the concave area of the petals with pale indigo, washing from the center outward.

6 Paint the convex side of the petal first in flat white before adding a little burnt siena wash along the outer seam of the petal to create contrast.

7 Wash the leaf and stalk with green, the front of the leaves with more indigo, and the leaf backs and the stalk with more yellow.

8 Finish by adding a little burnt siena on the new tips breaking out from the stalk.

birds

Although there is a vast number of different types of bird, for the purposes of art, Chinese painting divides them into the following three categories: the mountain, or land bird, the flying bird, and the water bird. Whether you choose the Meticulous or Freehand style, the structure and movement of the bird needs to be clear, and drawing from life is made easy. Though the body, beak, neck, wings, tail, and claw can be either long, short, thick, or thin—whatever their size or shape—the basic structure of each element is always the same.

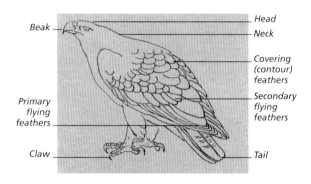

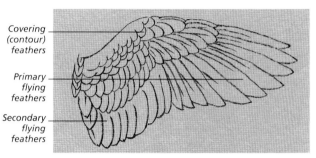

The contour feathers grow through the skin while the flying feathers grow directly from the bone of the wing.

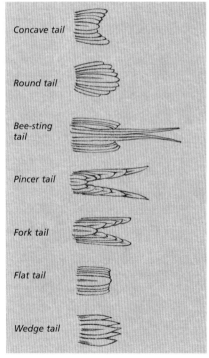

THE TAIL

Each bird has a differently shaped tail, depending on its lifestyle. When painting, look very carefully at the shape of the tail.

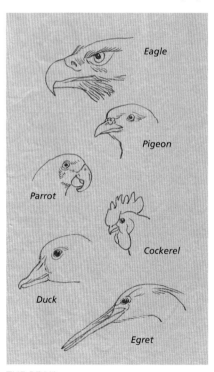

THE BEAK

The beak is one of the basic features to show the differences between the species, for example birds of prey have a hooked beak, mountain birds have triangular beaks for eating nuts, and water birds use long beaks to find food underwater. Study carefully the three lines of the beak; none are ever straight.

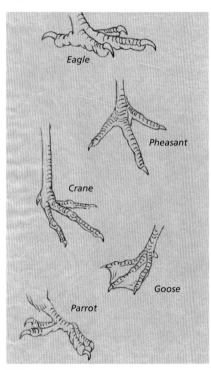

THE CLAW

Bird's feet also differ greatly, though most have three toes at the front with one pointing back. Flying birds have sharp claws; the land bird has to walk so its three toes are more open; and the water bird has webbed feet. One anomaly is the parrot, which has two toes on the front and two on the back

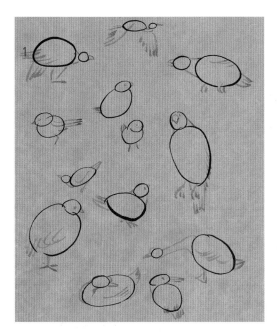

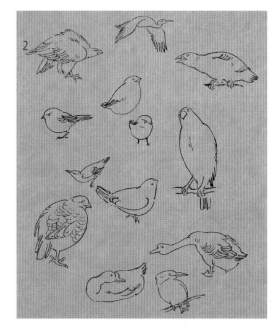

Compare the examples left and right, which reveal the basic two-oval structure of every bird—whether on land or in the air.

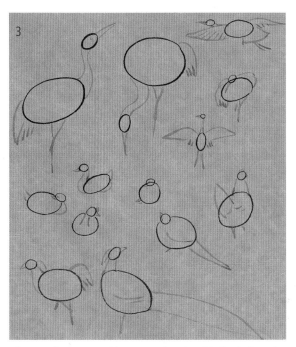

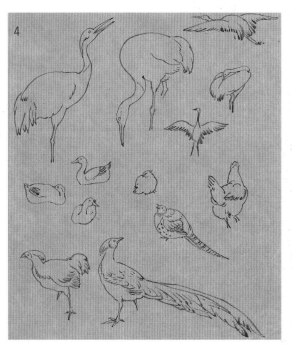

However large your subject remember that this simple formula works for every bird you will ever paint.

CAPTURING MOVEMENT

When painting a bird, at first ignore its size, beautiful feathers, colors, and detail; instead, remember that all birds are built from the same two basic oval shapes—the head and the body—and that its form depends on the size, shape, and positioning of these two ovals. The relationship of their position describes any type of movement, however complicated. Keep these ovals in your mind. Never draw them when actually painting, but you can place a sketch under your paper as a guide. Further to the position of the head and body, you only add the different details of beak, neck, leg, tail, and color to show various species.

Many birds are almost identical. Figures 1 and 2 (above) show how small birds, like the robin and sparrow, are formed from two almost identical ovals, one on top of the other. Figure 3 shows how placing one large egg with a small one at a distance will form any of the heron, crane, and flamingo in figure 4. The basic shapes of the pheasant and the goose are the same; the difference lies in the length of the tail and neck and contrasting beaks and feet. The shape, distance, and position of the two egg shapes show the movement of the bird while the individual species is shown by the outside details, the wing, tail, and claw.

flying birds

Graceful and silent, the seasonal flight of the swallow brings joy not only to China but throughout the world and is a popular Literati

motif. The Yellow Bird, or bee-eater, is represented in the celebrated, detailed Meticulous Song Academy style of 960–1271.

1

5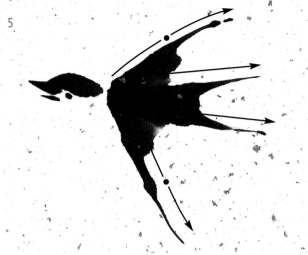

LITERATI FLYING BIRD—SWALLOW

1 Head
Always start with the beak. Use the stiff brush to mark two sharp, long dot strokes (see page 32).

2 Position the eye behind the top beak, just above the center line of the beak.

3 Use the bigger, soft brush to add the long dot of the top of the head.

6 Neck and throat
With light ink, mark the chest and stomach in a single stroke and then add a spot behind and under the tail.

7 With the work still wet, create a pale red dot, just merging with the chest, to make the neck.

8 Add dark ink under the swallow's body to form a claw.

BRUSHES

Use two brushes: the stiff orchid-

bamboo and the softer

"magnolia stamens."

4 Body and wings
For the body and tail use just two strokes. Press the brush, drawing the body in one long stroke before lifting so that the tip is used to make one side of the tail. Immediately make a second sharp stroke for the other side of the tail.

5 The wings are also each made from a single stroke. Follow the stroke diagram for each. Moving away from the body, with the brush pressed down, hesitate, lift a little and carry on, hesitating again before lifting the brush away to mark the long wing tip. Always ensure that the front of the wing is one continuous line.

7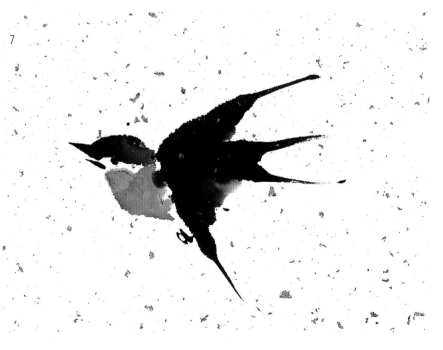

永 TECHNIQUES

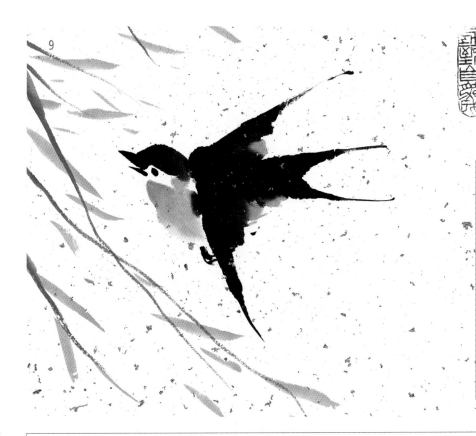

9

9 Background

Add a few willow leaves in indigo and green to show the wind; alternatively, combine swallows with peach blossom to indicate the spring.

Alternative: the lower view
When seen from a different angle the bird's back is obscured, so use lighter ink and reposition the claws.

METICULOUS FLYING BIRD—YELLOW BIRD

Use one small red-hair or crabclaw brush and two white-cloud brushes.

1 Transfer the ink lines from the design sheet, always following the same sequence: beak, eye, head, wing, body, tail. Ink wash the very dark areas of the wing, tail, and feathers a few times until the right shade is reached.

2 Wash the beak in purple, working from the head to the tip. When dry, use white washed in the opposite direction, merging the two colors.

3 Color the bird's head and the body in a combination of burnt siena and vermilion, then the legs and claws with white.

4 Draw the fine feathers in yellow mixed with white over the body wash. Don't rush, be patient and do each one separately.

5 Finish the bird by including the fine lines on the flying feathers in dark ink.

6 Add the appropriate background plants of your choice.

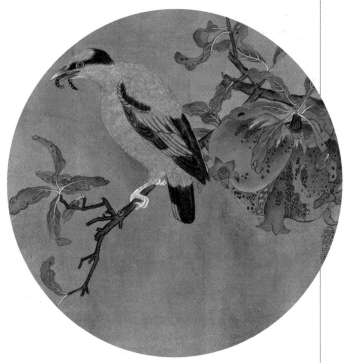

The Yellow bird in Song Academy style

water birds

Tranquil and contemplative, water birds add peace to a painting and give it an "eye" or focus. Usually with a long neck, a short tail, and a long beak, the main variant is that some, such as ducks and geese, swim while others, such as cranes and herons, wade.

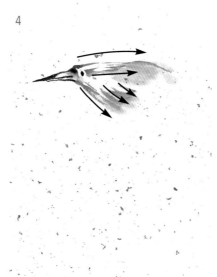

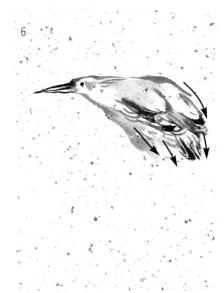

LITERATI WATER BIRD—EGRET

1 Beak
Start with three dark ink lines for the beak. Add the eye with a fourth touch just behind the beak slightly above the center line.

2 Highlight using light ink just behind the beak and again behind the eye with a little touch, allowing the ink to run a little.

3 Head and shoulders
Use the stiff brush for the head, shoulder and chest. Light, single strokes, as in the stroke diagram above, create the best effect.

4 Swapping to the soft brush, use pale ink to soften the previous strokes.

5 Wings and tail
With the stiff brush and dry, light ink arrange the feathers, wings and tail.

6 Now cover these light lines with a few dark ink strokes, allowing the different ink colors of to merge naturally.

7 Background
Use dark ink strokes for the legs before adding a few free strokes for the surrounding.

BRUSHES
Use two brushes: one orchid-bamboo (stiff) and one white-cloud (soft).

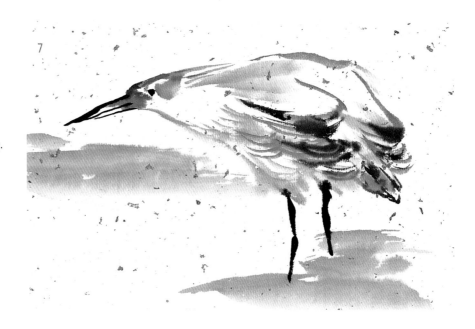

9 **Alternative: the upright view**

9 **Alternative: the upright view**

With the egret in a more upright position, the ink shades combine to complement each other. Use positive, free, brushwork. For background plants, try an indigo and yellow wash, and finish with highlights of mineral green.

METICULOUS WATER BIRD—EGRET

Use one red-hair and two white-cloud brushes. When painting a white bird, use the background color of the paper to emphasize the brilliance of the bird's feathers. Washing over the paper in white before you start gives a brightness that would be difficult to achieve if done after the picture was begun: use half the effort to achieve double the effect.

1 Start with the dark, fine ink lines of the beak and eye. Follow with light ink lines to draw the bird, moving from the head to the neck, shoulder, chest, wings, tail, and finally the legs.

2 Ink wash the beak, eye, and leg. Add a light ink wash over the feathers and body to form the bird in three dimensions.

3 Use a yellow to wash the beak, now from the eye, forward to merge with the dark wash added previously.

4 Wash around the eye, neck, shoulder, and wings, as well as on the upper planes of the ink wash, in pale burnt siena.

5 Make up a dilute white wash for the lower areas. These will mix eventually with the previously washed areas above. Color the legs in pale indigo.

The Egret, painted in Song Academy style

6 Draw in the long delicate feathers of the bird's head and wings in white.

7 The background can either include relevant plants—in this case lotus—or simply water or mist.

land birds

Ideal to draw from life, land birds—whether chicken, turkey, or ostrich—are characterized by small wings and very strong legs. Whether painted alone or as a group, bear in mind the two-oval structure will capture their movements clearly as they roam.

2

3

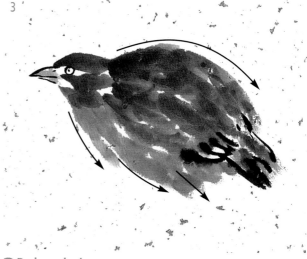

LITERATI LAND BIRD—QUAIL

1 Head and neck
Use the stiff brush to draw in the beak and eye.

2 Mix ink with burnt siena and use the softer brush—holding more ink near the tip—to draw the dot strokes for the head, chin, and neck, moving from front to back to give the darkest tones at the front of the head.

3 Body and wings
Mix ink with burnt siena and work, stroke by stroke, from the shoulder back through the wing to the tail. Use the diagram above to create sweeping strokes, long at the back and shorter on the stomach.

4 Dip the brush in a little bit of water to work through the stomach—creating a slightly paler color as you paint downward.

5 Immediately use the stiff bush with dark ink to draw the tips of the wings and tail.

6 Legs, feet, and claws
Use dark ink to draw the leg and claw and black dots on the body.

BRUSHES

Use a stiff orchid-bamboo and a soft white-cloud brush.

6

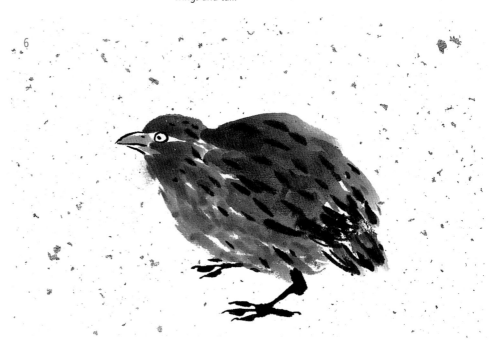

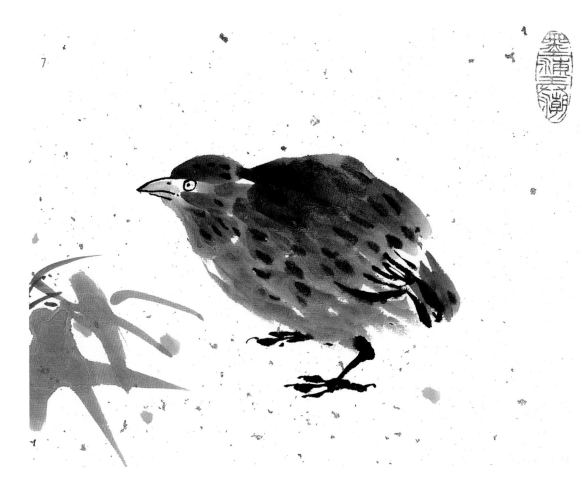

7

7 Background
Use a very few strokes for the surroundings, in this example bamboo in mineral green with a yellow dot.

METICULOUS LAND BIRD—QUAIL

Use one small red-hair and two white-cloud brushes.

1 Transfer the image from this illustration using ink line drawing, working from the beak to the eye, head, neck, back, chest, and feathers, finishing with the tail and claws.

2 Ink wash over the beak, face, feathers, and tail, repeating over the darkest parts. Never try to get the full darkness in one wash.

3 Use a dark brown wash of burnt siena mixed with ink to work the head, shoulder, body feathers, and claws. The stomach has warmer tones compared to the shoulders so use less ink.

4 Use diluted white paint to make the dots on the head and the fine lines of the cheek and the neck and along the quills.

5 The surrounding can be any mountain or woodland scene—this picture shows early spring.

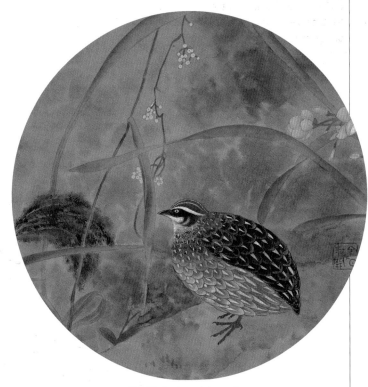

The Meticulous-style quail

format and paper cutting

Ever-present in Chinese painting are the particular formats and subject arrangements. Traditionally treated together in Chinese art, shape and composition techniques have been honed for centuries, and there are now established styles that offer your work immediate authenticity. While Chinese artists choose from many types of paper, as well as wood, bamboo, and silk, the most typical form is the scroll. Whether large or small, vertical or horizontal, scrolls can be mounted and hung, or kept rolled. However, modern developments in paper production and cutting techniques are gaining in popularity, and many paper shapes today are suitable for mounting in a glazed frame. Choose your scroll or paper size according to the spirit of the painting you wish to create and then study the internal composition guides to arrange the subect as a whole, allowing the best flow of *chi*, or vital energy, to your work.

Central Hall painting—Zhong Tang Hua
This type of painting should hang as the focal point of your home's main room. Normally it is a large size with a complicated subject, creating a feeling of magnificence that dominates the entire interior.
How to cut the paper:
Use an entire sheet of Xuan paper (see pages 22–23), painted either vertically or horizontally. Choose a four-, eight-, or even twelve-foot sheet, depending on the size of the wall.

Four hanging scrolls—*Si Tiao Ping*
Developed from the idea of a screen, this hanging scroll combines four pieces of long, thin paper placed close together on the wall. Each picture could also be hung individually. The subjects could be the flowers of the four seasons, the Four Gentlemen, four different types of birds, or any combination of four subjects.
How to cut the paper:
First decide the length you want your painting to hang and then cut two sheets of four-, six-, or eight-foot paper in half vertically.

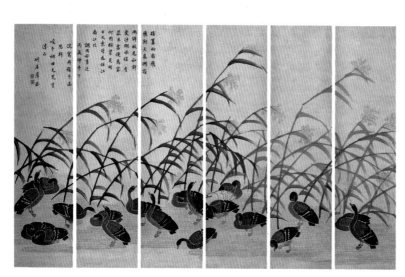

Panoramic screen—*Tong Jing Ping*
This type of painting hangs across a large area of wall, showing a panorama view. As the image runs from one paper to the next the screens should never include side borders, allowing the image to run from one scroll to the next. Normally the panorama is found in a set of up to twelve scrolls.
How to cut the paper:
Cut as many sheets of paper as required in half vertically, as for *Si Tiao Ping* above.

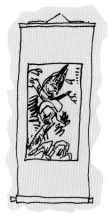

Vertical hanging scroll—*Li Zhou*

This is the most common type of Chinese painting. Its flexible size and regular format allows it to be hung in many different positions.

How to cut the paper: The Golden Cut

Cut a 1:2 ratio sheet evenly into three pieces, each one will be what is known in China as the Golden Cut ratio. When starting with a four-foot piece of paper, this method is also known as the "four foot, three cut."

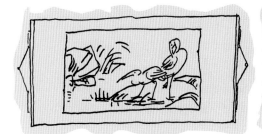

Horizontal hanging scroll—*Heng Fu*

This uses the same ratio as *Li Zhou*; in the West it can be hung above the fireplace or piano.

How to cut the paper:

Use the "three cut" method to achieve the Golden Cut ratio.

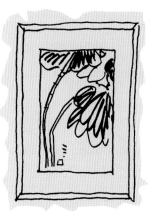

Framed painting—*Jing Pian*

This small format is ideal for framing behind glass in the normal, western way.

How to cut the paper:

For a smaller picture, prepare using the Golden Cut method. Then simply cut the paper in half, keeping the same ratio but halving the size.

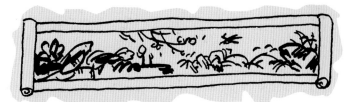

Hand scroll—*Shou Juan*

This is a long, narrow, horizontal painting showing a series of scenes that is normally approximately 1 ft. (30 cm) wide, whose length, in some cases, can reach dozens of feet. This type of painting should be viewed flat on a table while rolling the scroll from one scene to the next, just as though sightseeing when traveling.

How to cut the paper:

Cut foot-wide strips from any size of paper. Traditionally, lengths are then joined together to form long scrolls, though today long rolls of paper are available ready prepared.

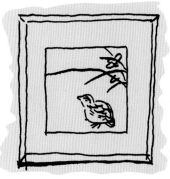

Square painting—*Dou Fang*

The square is normally small, hanging beside the bed or above a table to give a room some color, just like a pot of orchids in the corner. The image should have elegance without being overpowering; the image is normally framed.

How to cut the paper:

Cut a four-foot sheet of paper in half horizontally and then each piece into quarters, though square paintings can also be larger. Many modern Chinese artists choose this format, but it was very rare in ancient China.

Round Fan painting—*Tuan Shan*

A trimmed, square shape, originally used to make a fan, was very popular from the Song dynasty onwards.

How to cut the paper:

Cut paper into small squares, as for *Dou Fang* above, and then gradually shave away the corners so that the final shape is a very free combination of a circle and a square.

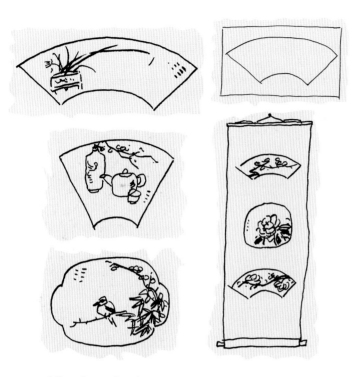

Folding fan—*Zhe Shan*

You can paint directly onto a ready-made fan or remove its structure and mount it flat, together with other irregularly shaped fans whose shape developed from it.

How to cut the paper:

Either buy ready-made fan papers, or use card stock to make a template from which to cut the paper.

Album—*Ce Ye*

This is a very popular way to collect small pictures. Normally eight, ten, or twelve pages long, it can be used as an artist's sketch book, a luxury gift, or as a souvenir of an important anniversary with many people inserting their own small pieces of work. When open, a painted page can sit next to a page of calligraphy or both pages can be combined for a horizontal picture. Alternatively, a side of the whole album can be painted with one long, horizontal picture.

How to cut the paper:

Albums are available in various ready-made sizes.

Triangle Composition

The most common way to arrange a Chinese painting, the form of the triangle depends on the direction in which the flower is growing. Usually two or three corners of the paper should be occupied. Always leave some space as a contrast between the density and clearness with the painted area appearing roughly as a triangle.

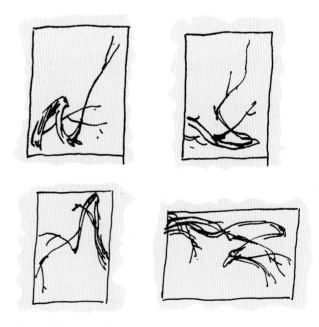

S-shaped Composition

As the branches of most plants do not grow in straight, repetitive shapes, form the plants from irregular curves that give the subject a sense of movement. Always work the brush in a general direction to ensure that the lines in your composition are never too straight or level.

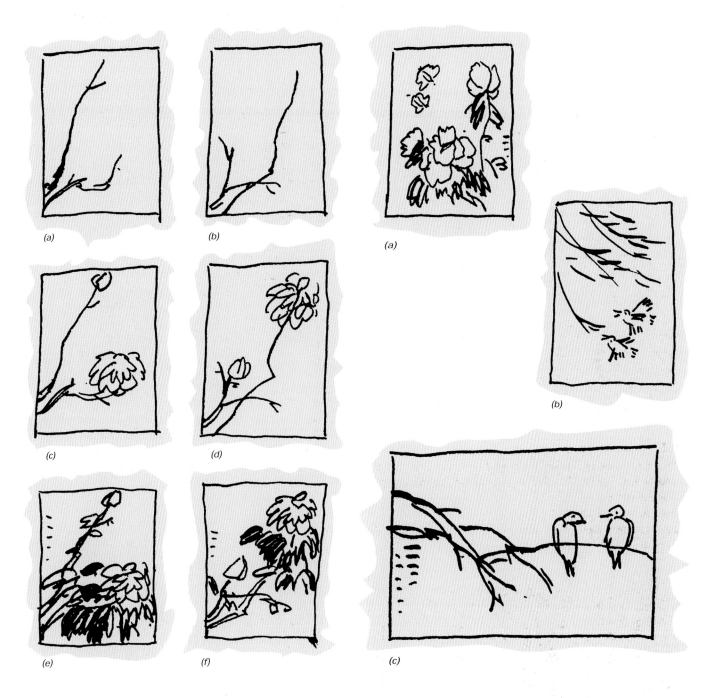

(a)

(b)

(c)

(d)

(e)

(f)

(a)

(b)

(c)

Key to Flower Arrangement

Flowers can be arranged in many different ways but there are a few simple points that are key to creating successful pictures:

• "One long, one short": Stalks or branches should never be the same length, see examples (a) and (b) above.

• "One big, one small": Contrast flower sizes. If a small flower is used high in the picture, it should be balanced by a large one lower down, see example (c), or vice versa see example (d.)

• "One more, one less": When adding leaves ensure a dense area of foliage is contrasted with an open one, see examples (e) and (f.) Never allow the picture to become symmetrical.

• When painting a more complicated composition, keep to the same rules, balancing a dense area of flowers with a more open area of buds.

Focusing on the "life spot"

In Chinese flower painting, the birds, animals, or insects will make the painting more lively and we usually use them to bring out the meaning of the picture, placing them in the focal point of the composition where they gather the *chi*, or spirit. The key principles are:

• "Mending the White:" If there is a large space, add a bird or animal. Some help tell a story, for example, combining butterflies with flowers shows that the picture is about fragrance, see example (a) above.

• Increase movement: Swallows show the wind and emphasize the sense of the movement of foliage, perhaps signifying a spring breeze, see example (b), while ducks or geese can help indicate the state of water.

• Telling the story: Use animals or birds to give the picture its meaning, showing a season, or an emotion or philosophical concept, see example (c.)

calligraphy and seals

Traditional Chinese art incorporates painting with poetry, calligraphy, and the seal in a single entity which has become known as the "Four Perfections:" As these express the artist's emotions, extend the meaning of the painting and increase the beauty of the art form. A good artist was usually required to be a master in all four disciplines. Calligraphy inscriptions became so important (often a good painting was felt to be ruined by bad calligraphy) that sometimes Chinese painters asked calligraphers to write the inscription for them.

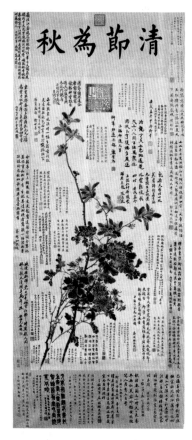

This painting by Pu Yi, the last emperor (1906–67), has been surrounded by the poetry and inscriptions of many admirers in various calligraphic styles in honor of the artist.

Pre-inscription *Ti* and post-inscription *Ba*

Mounted painting can often be seen with many calligraphy inscriptions included around, and even directly on top of, the image. When integrated onto a painting, the calligraphy is called *Ti* and when at the end of the painting, such as a scroll, it is called *Ba*. On a hand scroll empty space is deliberately mounted between the scenes to allow further inscription to be added. Sometimes a picture is full of inscriptions to show how significant it is.

There are three types of inscriptions:
- The expression of the artist's emotions, included as an integral part of the painting
- Inscriptions by other calligraphers, produced at the same time as the artist
- Later inscriptions added through history

Inscriptions have five purposes:
- To compliment the artist
- To evoke the emotions the picture has caused its audience
- A mark of authentication
- Criticism or discussion on the artistic merits of the piece
- To record an event relating to the picture

Types of inscriptions include:
- The title of the painting
- Ancient writings or poetry that are of relevance to the picture
- Original poetry
- Proverbs or famous sayings

Signatures—*Kuan*
When you have finished the painting you need to find the best position to sign your name or pen name, usually including the date and the name of the place in which you painted it. If the painting is a gift the dedication should also be included here.

Forms of Inscription and signature

Simple signature:
Just write down your name followed by your individual seal.

Short inscription:
As well as your name, include your age (especially if you are particularly young or old), your hometown, and the site where you painted the picture.

Signature with title:
The title should be short but written in larger characters than the following signature.

Long horizontal inscription:
With the top line level, arrange the characters from right to left reading downwards with no more than three characters in each column. The column length should be decided by the look it gives to the picture.

Inscription incorporated directly into the image:
This type of inscription can be difficult to manage, but it can be complementary to a bigger, simple object in a picture.

Tips for inscription & signature

- Never let calligraphy overpower a very finely worked painting.
- When adding calligraphy to a strong painting, the characters can be small but never soft or weak.
- On large, Freehand work the calligraphy should not be too tidy.
- Don't try to include too many characters; they can ruin a good painting.
- Any calligraphy style can be used for the inscription as long as the style of the painting remains prevalent For example, write the painting title with *Zhuan Shu* script, personal signatures in a running script, and always use standard script on a Meticulous painting.
- If a picture would benefit from no calligraphy, simply print a seal in a suitable place to identify yourself as the artist.
- If you have produced a work along with somebody else, sign the work next to the element you painted yourself.
- A good painting can be ruined by bad calligraphy.

The Printed Seal — Yin Zhang

The seal is the artist's identification, an integral part of his signature, and, as such, an integral part of the picture. There are two types that both identify you as the artist: (1) the name seal, which might be a pen name, and (2) the message seal, which includes a saying or phrase relevant to you. The name seal is a regular, square shape while a message seal can be any shape. They can be *yang*, showing red characters on a white background, or *yin*, showing white against red. Use red printing paste, or artificial cinnabar-colored red printing paste if it is availible. The position of the seal should be chosen carefully. Place the name seal underneath or beside your calligraphy signature, depending on the painting's composition. If you wish to print two seals, ideally use one *yin* and one *yang* seal. Always use cinnabar red printing paste. A third seal is often a free message seal and should be placed in the opposite corner to the name seal. The message seal can be used in many different ways, all depending on the composition of the painting. There are some famous rules: "putting weight on the bottom corner" to balance a composition or "mending the white" to fill a large blank area.

Some seals of the author:

The five square seals on the top row are name seals. All the others are message signs, including the three large, corner-weighted seals on the bottom row. None are used always, each is appropriate to a certain type, style, or subject and helps to emphasize the emotions of the piece.

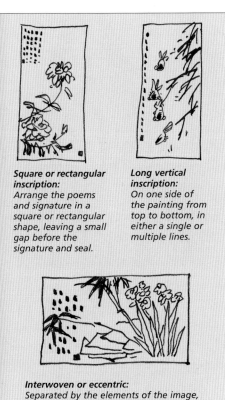

Square or rectangular inscription:
Arrange the poems and signature in a square or rectangular shape, leaving a small gap before the signature and seal.

Long vertical inscription:
On one side of the painting from top to bottom, in either a single or multiple lines.

Interwoven or eccentric:
Separated by the elements of the image, for example between bamboo poles.

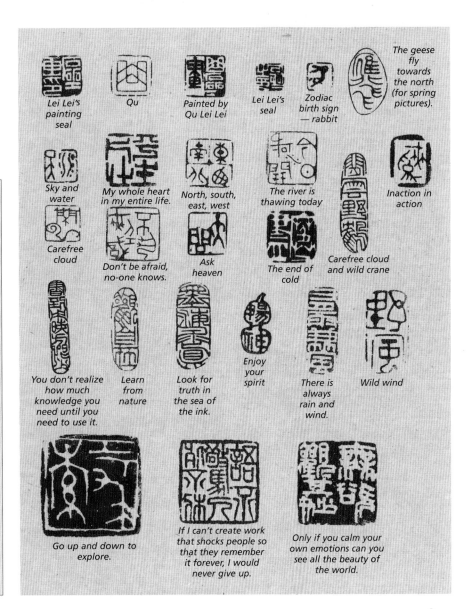

Lei Lei's painting seal

Qu

Painted by Qu Lei Lei

Lei Lei's seal

Zodiac birth sign — rabbit

The geese fly towards the north (for spring pictures).

Sky and water

My whole heart in my entire life.

North, south, east, west

The river is thawing today

Inaction in action

Carefree cloud

Don't be afraid, no-one knows.

Ask heaven

The end of cold

Carefree cloud and wild crane

You don't realize how much knowledge you need until you need to use it.

Learn from nature

Look for truth in the sea of the ink.

Enjoy your spirit

There is always rain and wind.

Wild wind

Go up and down to explore.

If I can't create work that shocks people so that they remember it forever, I would never give up.

Only if you calm your own emotions can you see all the beauty of the world.

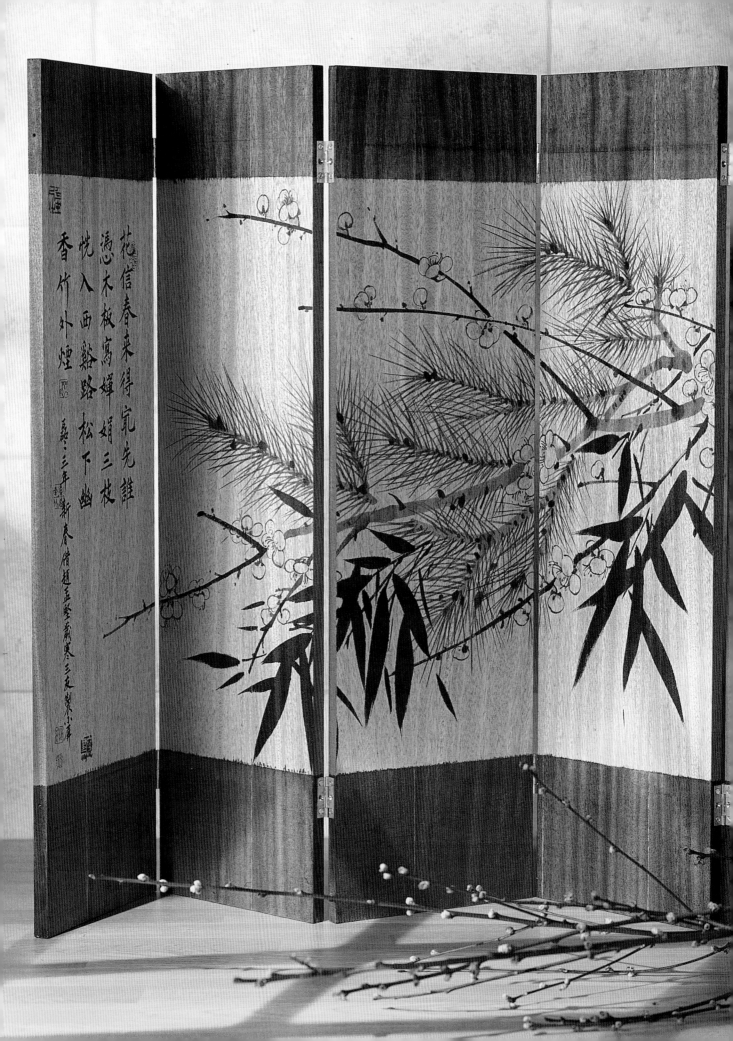

我家洗硯池頭樹箇々花開淡
墨痕不向人誇好顏色只留
清氣滿乾坤
三年新春磊々

the projects

Practiced for more than 1,000 years, the art of brush painting is never more elegant than when it is put to practical use. The authentic projects in this section show you how to create lasting works of art with the classic motifs of the "Four Gentlemen" used in the different styles of painting through the ages, including the precise Meticulous school and the looser, more inspired Freehand style. Including simple projects, such as the lilac orchid talisman and a series of colored bamboo paintings, as well as classic black-and-white works, the projects also make use of traditional Chinese forms. The series of fan projects includes a round parchment fan decorated with bamboo and birds, which is suitable for beginners. Painting on fabric, ceramic, and wood is important too. Try painting a blind with flying geese, a wooden screen, a zodiac mobile, and a goldfish-decorated kite.

bamboo in the wind

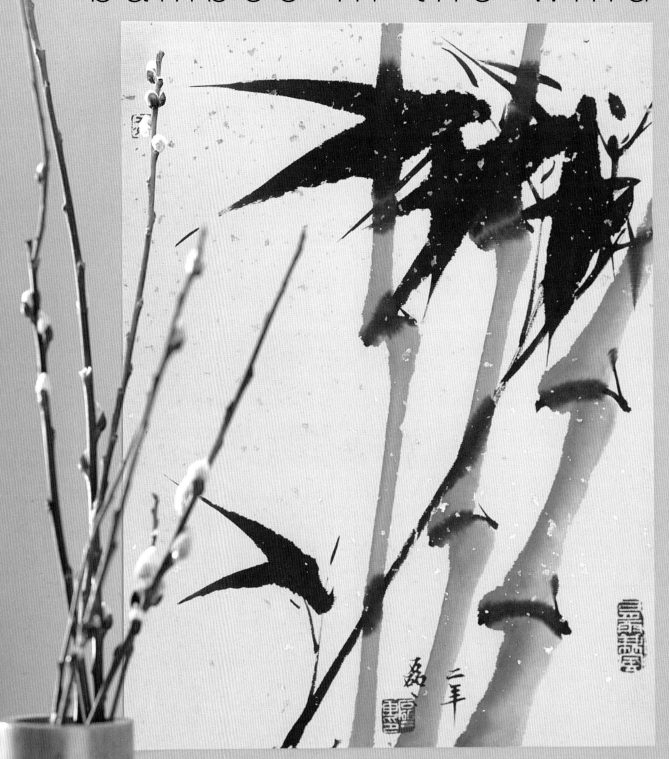

The seal on the right of the painting says, "There is always rain or wind." Here the bamboo, often painted as a symbol of the season or an emotion, is bending before a stiff breeze in a mood of gentle optimism. The boldness of the dark leaves and thin branches is offset by the paler gray of the thicker poles of bamboo. The Freehand, Literati style of painting is suited to this kind of subject.

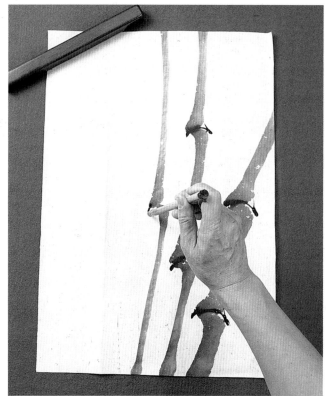

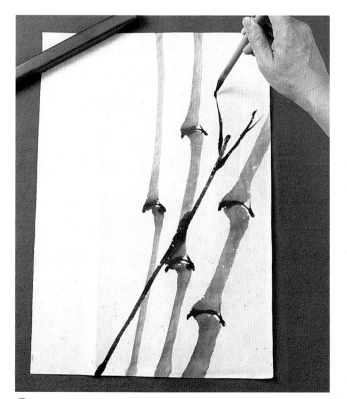

1 Following the bamboo painting technique (pages 42–44) and using the large, mixed-hair brush, paint the poles of bamboo.

2 Working quickly, before the ink dries, paint the joints in the bamboo. Use the medium, long-tipped, stiff-hair brush, keeping the ink dark.

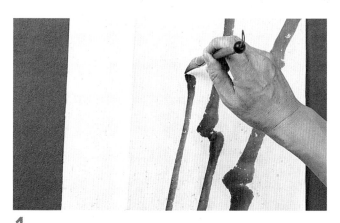

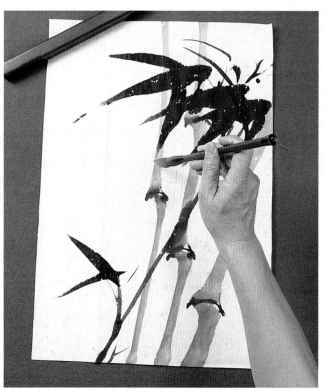

3 With the stiff-hair brush and dark ink, paint a strong, thin branch across the poles. At the top, divide into a "bird's claw," ensuring that the short strokes are well-positioned for the addition of the leaves.

4 Using the large brush and very dark ink, add the leaves. Concentrate them at the top of the thin branch, with just a couple at the end of a thin shoot at the bottom. Finally, sign with a seal in red paste.

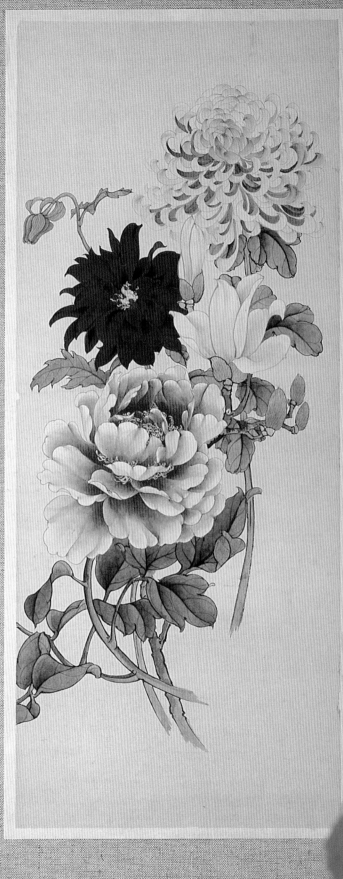

flowers
for four
seasons

This Academic-style study brings together flowers from all four seasons—the magnolia of spring, the peony of summer, the chrysanthemum representing fall, and the winter dahlia. The image is felt to be so calming that in China it has come to be referred to as "lying down when traveling." Paint each flower in turn, but don't let the flowers painted first dominate the picture. Ensure that the whole composition always stays clearly in your mind from the moment you set out your materials.

YOU WILL NEED:

Sized Xuan paper or sized silk:

48 x 24 in (120 x 60 cm)

Small, "red-hair" brush

2 small, mixed-hair brushes

Black ink

Colored pigments:

Indigo

Yellow

White

Carmine red

Burnt sienna

Seal and red printing paste

1 Magnolia—spring
Trace in pale ink from your design sheet using a small, "red-hair" brush.

2 Cover the petals with a general base wash in white using a small, mixed-hair brush.

3 Using two mixed-hair brushes, give the petals a soft green wash. Place light-colored paint toward the bottom of each petal before immediately the second brush to wash clean water over the top.

4 Use a burnt sienna color wash to cover the calyxes, working the brush from the bottom upwards.

5 Add hairs to the calyxes with the line-drawing brush in burnt sienna mixed with a little black ink. Also add small indigo highlights to the stem.

1 Peony—summer
Trace in pale ink from your design sheet using a small, "red-hair" brush. Cover the petals with a general base wash in white using a small, mixed-hair brush.

2 Paint the inside edges of the petals in carmine red and then wash the color outward using the second brush and clean water. Let the darkest color remain at the petal edges.

3 While the first layer is drying, put a flat coat over the stalk in light green from a mix of indigo and yellow. Add red over the top and feather to create the shape of the stalk.

4 Using a colder, stronger red, highlight the petals. To emphasize their jagged edges, place the brush at the top of the petal and drag the point of the tip down while the previous wash is still wet.

5 Add stamens in a very creamy mix of yellow and white using tiny curved strokes and dots.

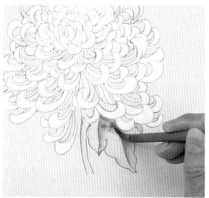

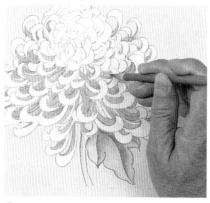

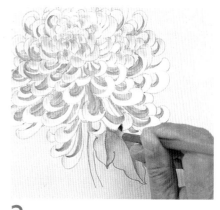

1 Chrysanthemum—fall
Trace the flower from your design sheet using a small, "red-hair" brush with pale black ink. Cover the petals with a general base wash in white using a small, mixed-hair brush. Give the stalk and leaf a base coat of pale indigo.

2 Fill the inside surfaces of the petals in a deep orange, mixed by combining carmine red and yellow inks.

3 Highlight the inside surfaces of the petals before adding a pale wash in the same color over the outer edges of the petals.

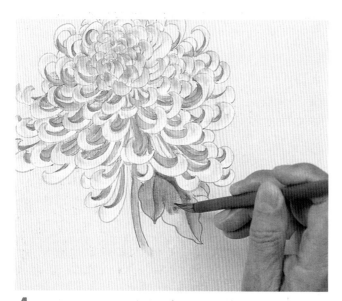

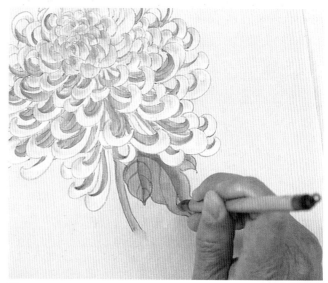

4 Create a yellowish wash by adding a little indigo to yellow ink and use it to cover the leaves stroke-by-stroke.

5 Add fine veins to the leaves with indigo lines, using the very end of the brush tip.

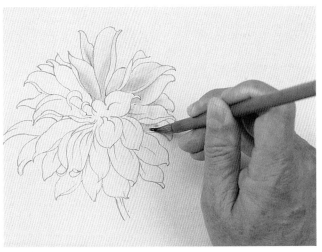

1 Dahlia—winter
Trace in ink from your design sheet using a small, "red-hair" brush. Shade the petals with an indigo wash using two mixed-hair brushes.

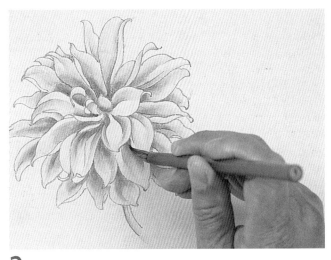

2 Continue creating the shadows in petals with a dark indigo wash.

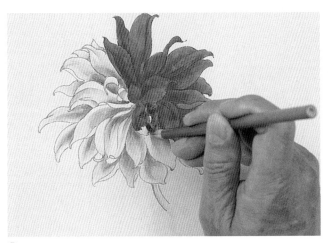

3 Cover the petals in a single coat of strong, rich red—known to the Chinese as "big red"—that still lets the indigo shadow show through.

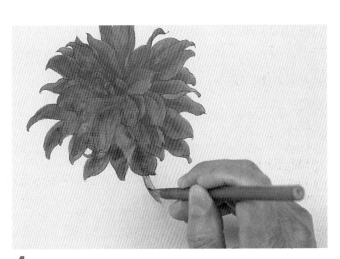

4 Mix a green wash from indigo and yellow and cover the stalk.

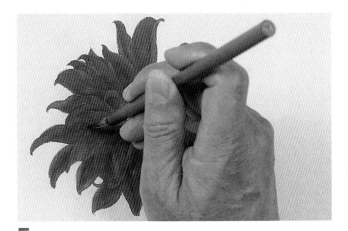

5 When the petals are dry, add black highlights—the ink softened with a touch of indigo—to achieve the dahlia's velvety feel, washing the color over the petal in the usual way.

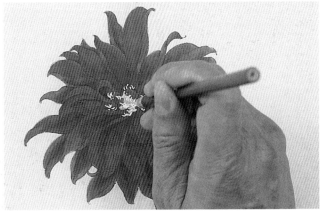

6 Finally, create a strong, fresh green from indigo, yellow, and white pigments and cover the center of the flower. Use this as a base for bright yellow stamens. Seal your work.

bamboo, blossom, and pine screen

Don't confine your brush painting to paper and silk. Ink can also be used to decorate any wooden item from the smallest box to large pieces for your home like this folding screen.

Use the differing shades of black ink, from burnt charcoal through pale gray, to emphasize the various qualities of the plants, the delicacy of the blossom, the sinewy strength of the bamboo, and the wispy, long lasting nature of the pine. Ensure the whole finished image is clear in your mind from the outset. By following the process carefully, and painting each plant in turn, the composition will come almost magically to life. Finish by including some poetry worked in calligraphy, allowing even your home furnishings to be true "voiceless poems."

YOU WILL NEED:

Six pieces of 32-in x 9-in (80-cm x 23-cm) veneered chipboard or timber
Masking tape
Large, soft-, or mixed-hair brush
Medium, stiff-hair brush
2-in (5-cm) decorating brush
7 fl. oz. (200 ml) medium-dark wood dye
Black ink
Polyurethane gloves
Turpentine (white spirit)
Rough card stock
Ten 2-in (5-cm) hinges plus screws to fit
Screwdriver
Clear matt acrylic varnish
Seal and red printing paste

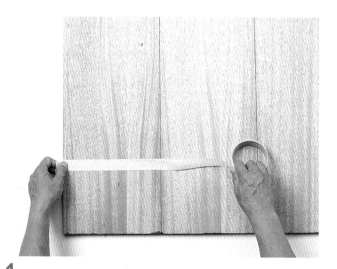

1 Place the boards side by side. Measure 6 in (15 cm) from the base of the boards, marking at either end before masking the area off with a straight line of tape.

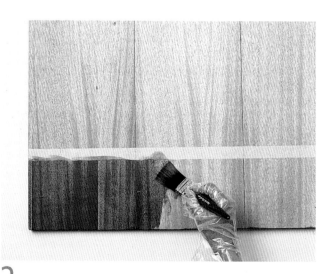

2 Wearing the polyurethane gloves for protection, paint the masked area lightly with wood dye. Repeat at the top, here placing the tape 4 in (10 cm) from the upper edge. Allow to dry and remove the tape.

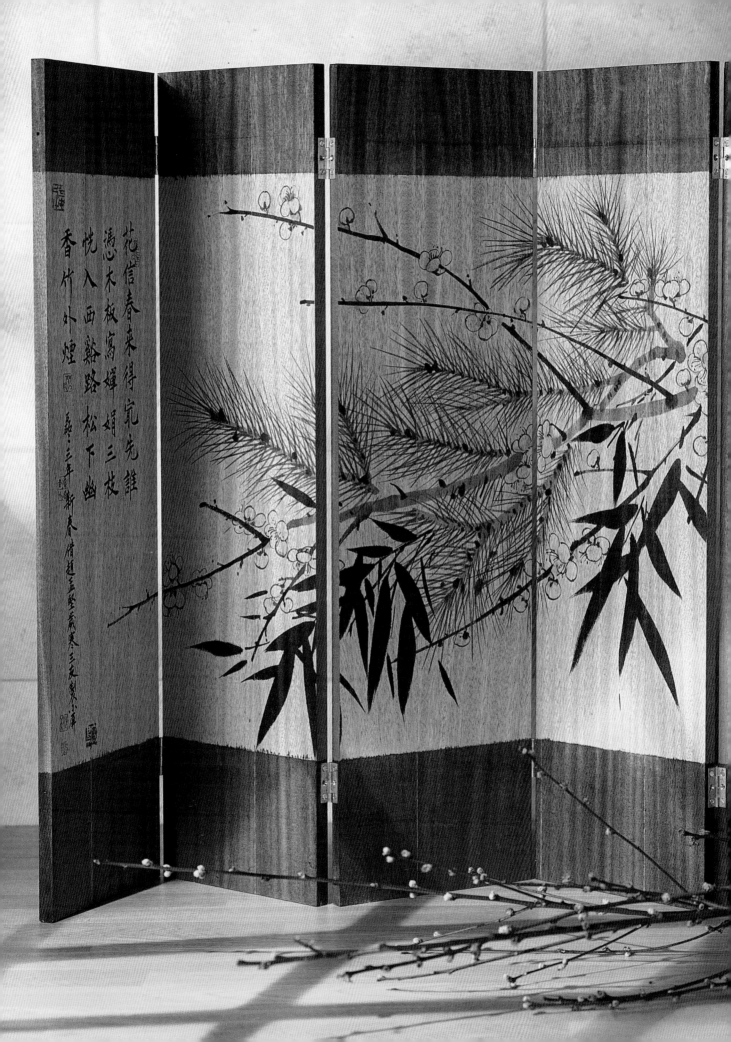

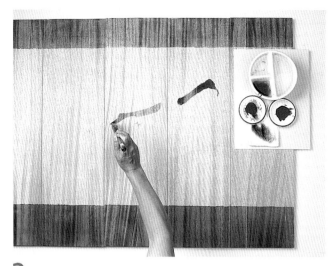

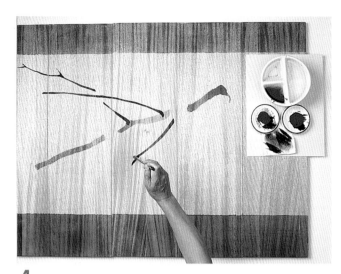

3 Ensuring all your materials are close at hand, mix a quantity of ink. Then place your brushes, ink, and water container on a piece of rough card stock in one corner of the screen. Using the soft-hair brush, start painting the main blossom branch, working from top right to bottom left (see page 34 for the correct strokes to use).

4 Create the three slim stems with the stiff-hair brush, each stem running away from the main branch at varying angles. Now add the smaller branches with shorter strokes (see page 32). Then use dot strokes (see page 33) to add the buds and knots.

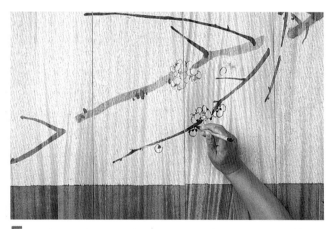

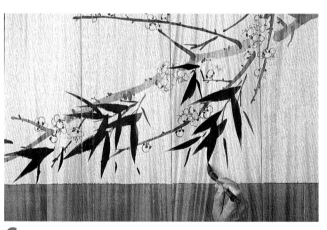

5 Using the stiff brush, draw blossom petals, each one drawn by two rapid, curving, light strokes around the blossom's center. As you continue, make sure your strokes remain light, delicate, and paler than the branch and stems. Finish each blossom with "nailhead" strokes for the stamen (see page 36) and small dots for the pollen.

6 With the blossom complete, begin to include the bamboo. First, use a stiff brush to paint the branches in black ink, including "bird's claw" divisions (see page 43). Then, using the thick brush, add in the leaves, each in a heavy, single strokes. Position them in groups of two leaves as "swallow tails" or "fish tails" (see page 44).

7 Paint in the main branch of pine with a stiff brush, making sure not to overpaint the blossom or bamboo, and add texture, using light hatching strokes of the brush with a darker shade of ink. Immediately add in twigs and smaller branches.

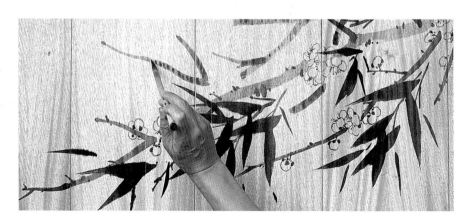

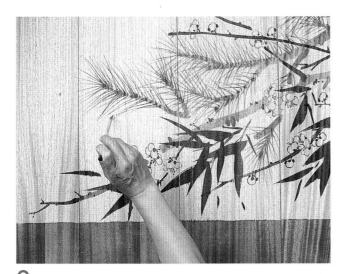

8 Using dark, feathery strokes, sweep in the pine needles on the stems. Working the brush away from the stems, lift the brush away sharply from the surface as you reach the end of each pine needle.

9 Include poetry or sayings in calligraphy down both side panels using black ink. Finally, apply the seal firmly in red printing paste.

10 Leave the screen for 24 hours to dry thoroughly. Affix the hinges in a concertina shape. To seal, coat the screen with a spray of clear matt acrylic varnish.

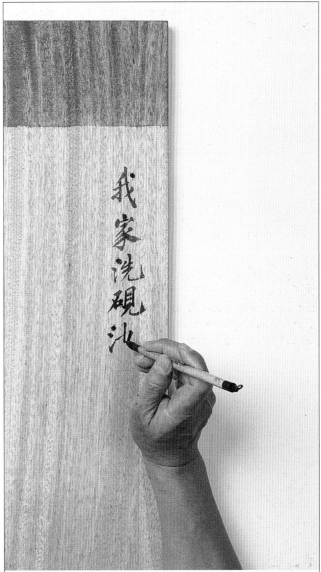

Translation of the calligraphy

In the tradition of brush painting, where the combination of painting and writing is believed to represent the highest art form, your work should be finished with a verse or saying in calligraphy. The ancient poems (see pages119–127) celebrate the beauty of nature and the coming of spring as expressed by the painting's subject— *The Three Friends of Winter*: the bamboo, pine, and blossom.

Outside my house, a group of trees grows by the pond.
As the seasons turn and winter moves to spring, the flowering arrives: a fresh splash of ink, dissolving over rough board.
My trees have no interest in displaying showy blooms and gaudy color; they exist beside my pond for nothing but to reveal the fragrance of silent strength and elegance to the world,
The true messengers of the spirit of spring.

Even though I have painted just these three branches on a piece of bare wood,
You can smell the fresh scent of new pine,
You can see clouds of blossom trailing like mist across the clean sky.

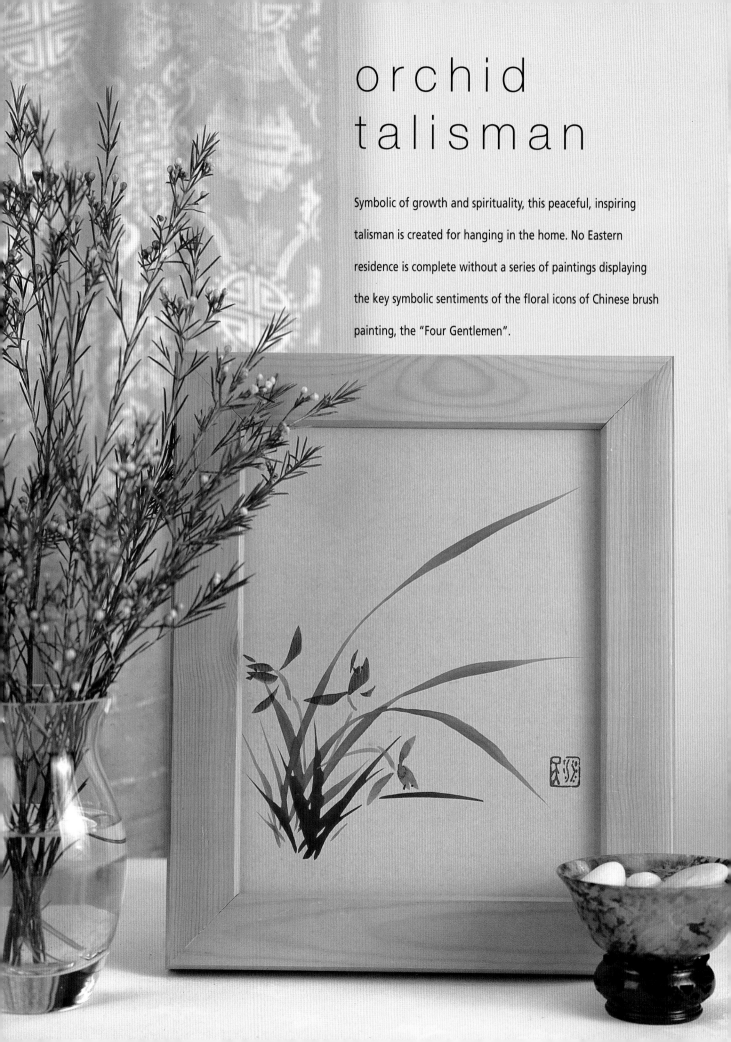

orchid
talisman

Symbolic of growth and spirituality, this peaceful, inspiring talisman is created for hanging in the home. No Eastern residence is complete without a series of paintings displaying the key symbolic sentiments of the floral icons of Chinese brush painting, the "Four Gentlemen".

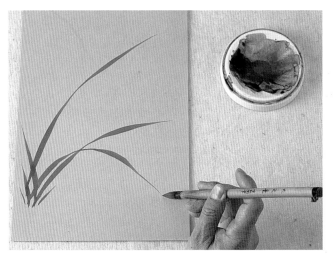

1 Once you have decided where to position your work within the proportions of the paper you have chosen, start by sweeping the brush across the paper in five simple strokes (see pages 38–39.)

YOU WILL NEED:

Colored paper
Medium, stiff-hair brush
Colored pigments:
Green ink
Lilac ink
Color-mixing dishes
Seal and red printing paste

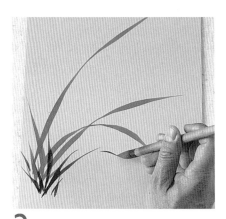

2 Continue with further strokes, varying in length, to create the thick clump at the base of your plant.

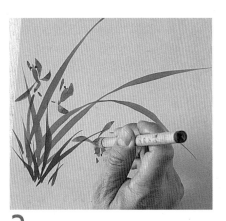

3 Wash the brush clean of green ink. Mix a strong lilac in a mixing dish and load the brush halfway up the tip. Choose the quantity and position of your flowers on the page and, using the orchid petal stroke (see page 40), paint the upward-moving petals.

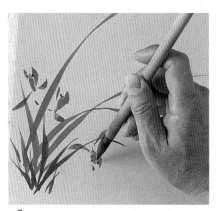

4 Add in the orchid's stamens using two or three springing dot strokes for each flower. Let the tip touch the paper at the flower's center before making a quick movement of the brush to create each stamen.

5 Wash the brush and reload it fully with a strong green pigment. Using a light pressure and the very tip of the brush, draw in the stems and stalks to link each flower to the root.

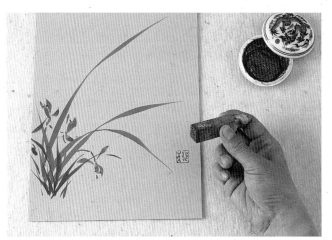

6 Placing the seal is key to balancing your painting. Using printing paste, dab the paste lightly and press down on the painting hard. Allow to dry thoroughly before mounting the piece (see pages 114–117.)

plum blossom painting

A simple and elegant image, this painting of plum blossom is soothing and calm. It uses just two colors—red and yellow—to create a wide palette of red tones that echo the black tonal range. As in all Literati-style painting, form and elegance are paramount. When using such a limited palette keep a careful watch on the picture's composition, keeping movement as simple as possible while remembering to retain space in which to seal the work with your signature.

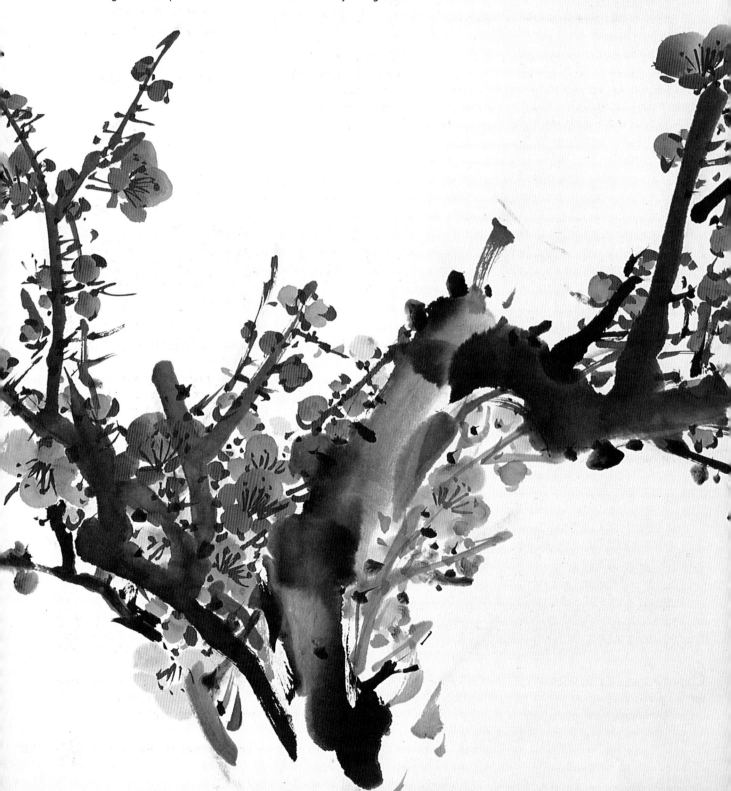

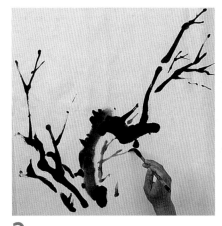

1 Mix a quantity of strong black ink. Using the large brush, create the thick main branch, following the techniques on page 34. Work upwards from the bottom of the picture, breaking each stroke at an angle and ensuring that the younger branches above are darker than the larger ones beneath.

2 Dilute the ink and paint the rear, paler branches and stems. Remember to have a clear idea of the whole composition so that you can leave gaps in the ink work where you will later place flowers.

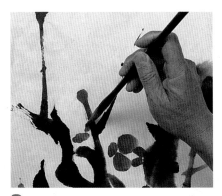

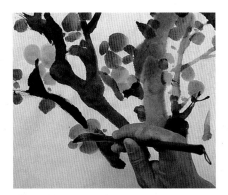

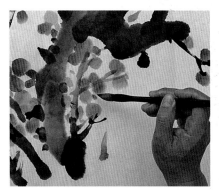

3 Load the medium, soft-hair brush with carmine red ink before dipping the tip in vermilion, allowing the tones to mix on the brush. Paint the larger blooms and buds with fat dot strokes. Ensure that flowers seen head-on include five petals.

4 Still working in single dots, dilute the red ink and paint paler blooms. Do not rinse the brush out as you load the new colors so that every blossom has its own unique shade. Next, add a touch of yellow to the carmine mix and paint the palest blossoms.

5 Use the small, stiff-hair brush to paint in the stamens, mixing carmine with black ink. Work in small hooked strokes that follow the direction of each flower.

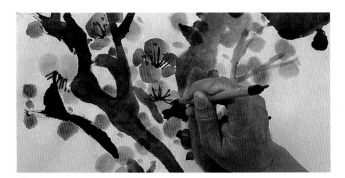

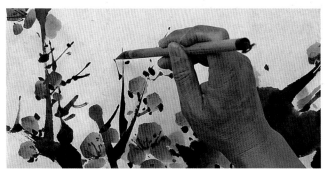

6 Work more black into the ink mix and paint in the calyxes as tiny, dark purple dots.

7 Add tiny twigs in a dark purple ink, using very short broad dot strokes with the medium, stiff-hair brush (see page 33) around areas without blossom. Finally, seal the image with red printing paste.

chrysanthemum painting

The chrysanthemum has been lauded for centuries in Chinese art as one of the almost mythical "Four Gentlemen." As a symbol of dogged strength, the flower became especially popular as a subject for the Literati painters that came to prominence during the Yuan dynasty.

This updated project combines a vertical format that echoes the very tall stems in the composition with striking color contrasts between the plants. As the Freehand painters would have, add depth and interest by varying the densities of the inks and ensuring that the colors vary from plant to plant and from petal to petal.

YOU WILL NEED:

Xuan paper – 14 x 36 in (35 x 90 cm)
Small, long-tipped, stiff-hair brush
Large, soft-hair brush
Medium, soft-hair brush
Black ink
Colored pigments:
Indigo
Red—vermilion, carmine, and bright red
Yellow
Seal and red printing paste

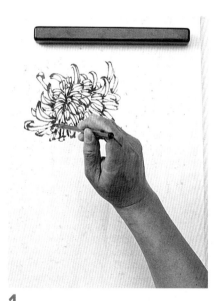

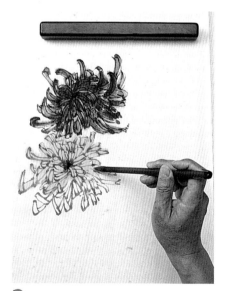

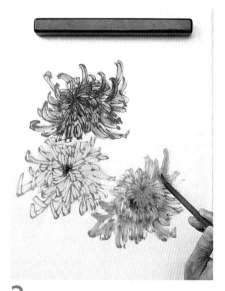

1 Mix a gray wash by diluting black ink. Use a fine, long-tipped, stiff-hair brush to paint the outline of the petals of the first chrysanthemum. Start at the center to fix its position, creating each layer of petals in turn and moving towards the flower's edge.

2 Immediately wash the chrysanthemum in red, using the medium, soft-hair brush. Returning to the original gray, outline the petals of the second flower before washing it in bright yellow.

3 Mix a pale purple from red and indigo inks and use to outline the petals. Wash over the third flower in purple. Then add the stamens in deep red, using light vertical dot strokes (see page 33), and highlight the flower's edges with bright blue.

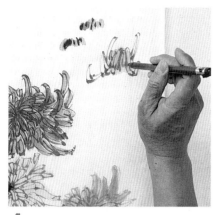

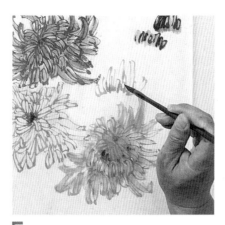

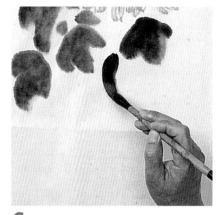

4 Paint the new buds with thick black strokes. Add the stamens with dot strokes in light ink. Then wash with a brush loaded mainly with yellow but tipped in red to create variable, orange tones on the flowers.

5 Add the final flower, combining purple petal outlines overlaid with a yellow wash.

6 Using a large, soft brush, paint the leaves in black ink mixed with a little indigo, forming each one from three individual strokes.

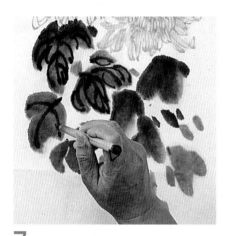

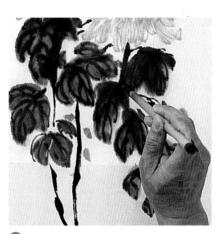

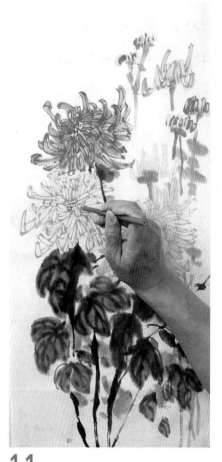

7 To add texture to the leaves, paint in the veins with a fine brush using black ink.

8 With the main areas of color now in place, insert the stalks. First, include the strong stems in the foreground, using a soft brush with the black-and-indigo mix.

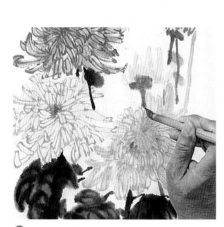

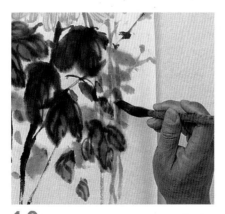

9 Add the stems of younger flowers using a fine brush and paler ink.

10 Place single leaves with dot strokes in pale ink at intervals towards the top of each of the smaller stems.

11 To finish, insert the stamens on the largest blooms, in a mix of yellow and white pigments on the red flower. Then add green and white pigments on the yellow one. Seal the picture using red printing paste.

bird and bamboo fan

The defining words of the Academic style of Chinese painting are "tranquillity" and "elegance," both of which are perfectly captured in this fan-shaped painting of a wading bird. The antiqued background throws the fresh colors of the bird and the bamboo leaves forward in the picture.

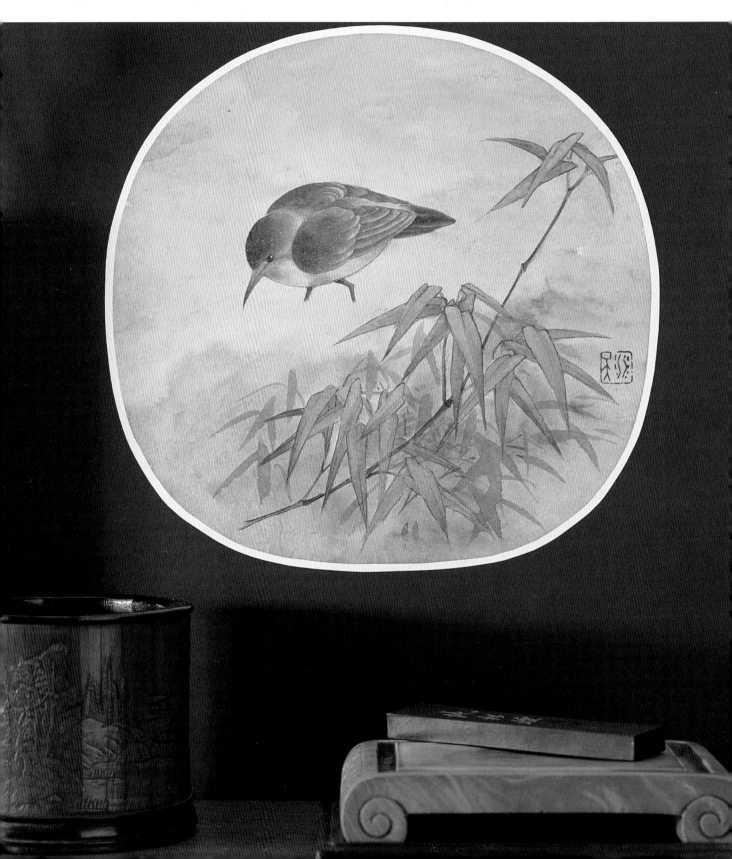

YOU WILL NEED:

Sized Xuan paper cut into a round fan shape

1 "red-hair" brush

2 small, mixed-hair brushes

Black ink

Colored pigments:

Brown

Indigo

Yellow

White

Orange

Dark green

Mineral green

Seal and red printing paste

1 Trace out your design onto a piece of sized, fan-shaped paper using the stiff, red-hair brush and pale ink. Continue until the outline of the entire bird has been traced.

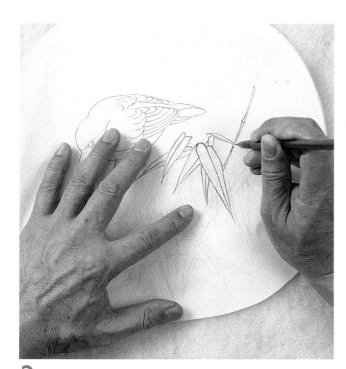

2 Continue tracing the bamboo until you have completed the design. Prepare the rest of your materials.

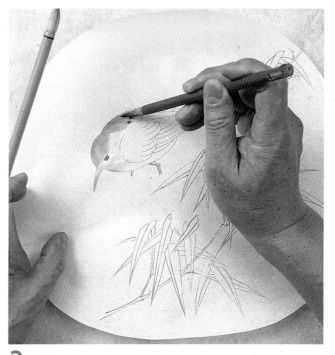

3 Using the two mixed-hair brushes—one for ink and one for water— follow the technique shown on page 31 to inkwash the bird. Use the wet brush (held in the left hand, above) to blend the ink from the right-hand brush into graduated tones.

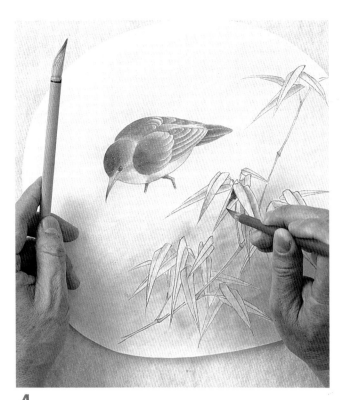

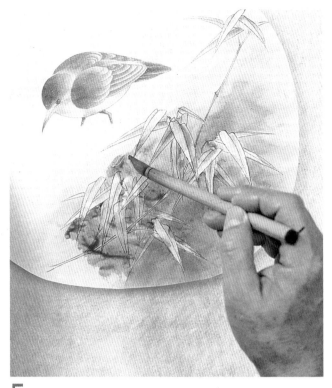

4 Following the technique for inkwashing bamboo (see page 45), add color to the plant and the surrounding area.

5 Still using the white-cloud brushes, colorwash the background in a dark antique brown, working around the bamboo. As you work across the background, lighten and warm the tint to a paler brown.

6 Allow the color to blend gently over the bird. There should be no hard lines at all. Brush out any concentrated flecks of paint with the wet brush.

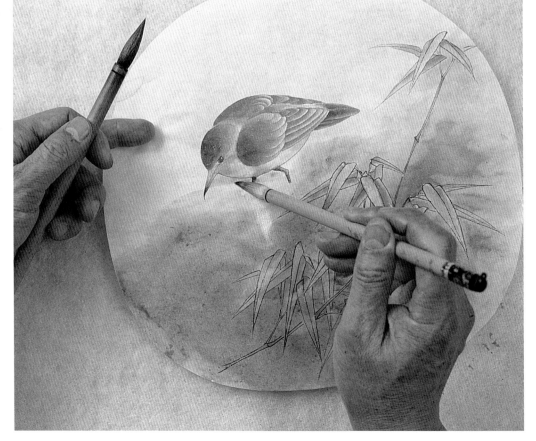

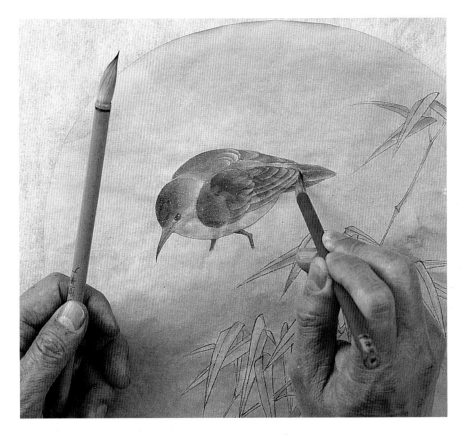

7 Mix an orange tint and colorwash the bird's beak and legs. Using pale yellow, colorwash the stomach and the middle of the back. With brown paint, colorwash the tail, wings, and the head, blending the color on the head into the yellow of the stomach.

8 Add a little more yellow to the bird's back and the base of its stomach. On the chest, add some white paint and blend it into the yellow with the wet brush.

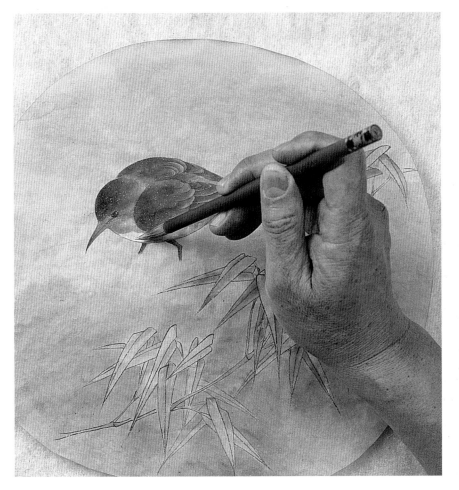

PROJECT COLORS

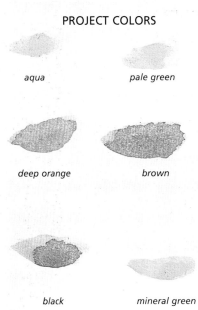

aqua

pale green

deep orange

brown

black

mineral green

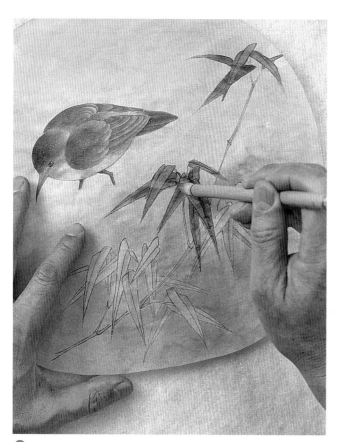

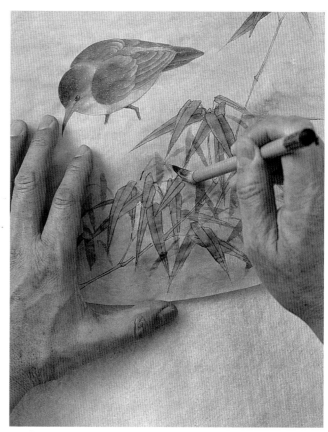

9 Colorwash the bamboo leaves in dark green.

10 Add a few extra bamboo leaves between the existing ones. Paint them in single brushstrokes, following the technique on page 44.

11 Paint the bamboo stems in a purple-brown tint.

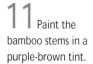

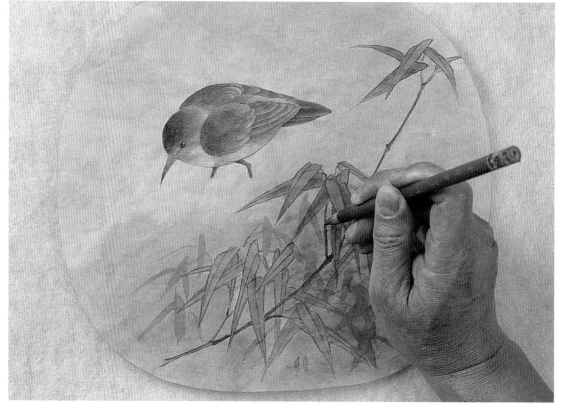

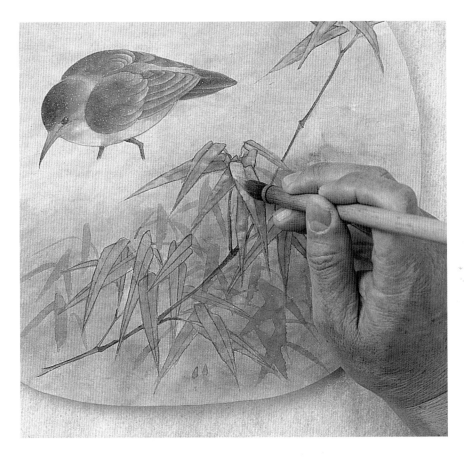

12 Add highlights to the bamboo leaves in the foreground. Paint the top section of each half of the leaf with mineral green. Use the wet brush to blend the color down the leaf.

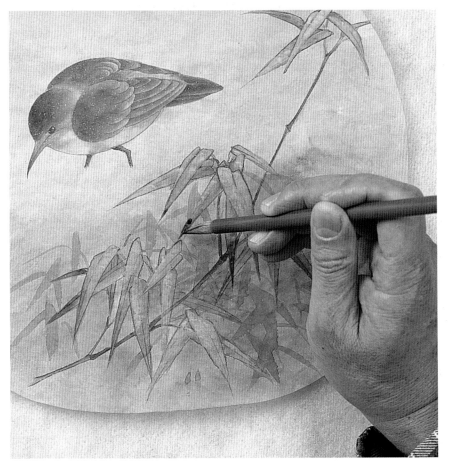

13 Add some shadow to the tips of some of the leaves and to some of the background leaves. Brush a little indigo paint onto the leaf tip and use the wet brush to blend the color up the leaf. Seal your work.

INKWASHING TIPS

Always use two mixed-hair brushes; keep one brush damp with water and the other one loaded with the ink.

As you paint, work away from the central design toward the edge of the artwork area.

If you are a beginner, paint and wash small areas at a time so that you do not need to hurry the inkwashing.

bird and plum blossom on bamboo

These sparrows, perching on boughs of plum blossom, are painted in the Academic style of the Song dynasty. The combination of flowing ink wash and fine detail is typical of this very precise style of painting.

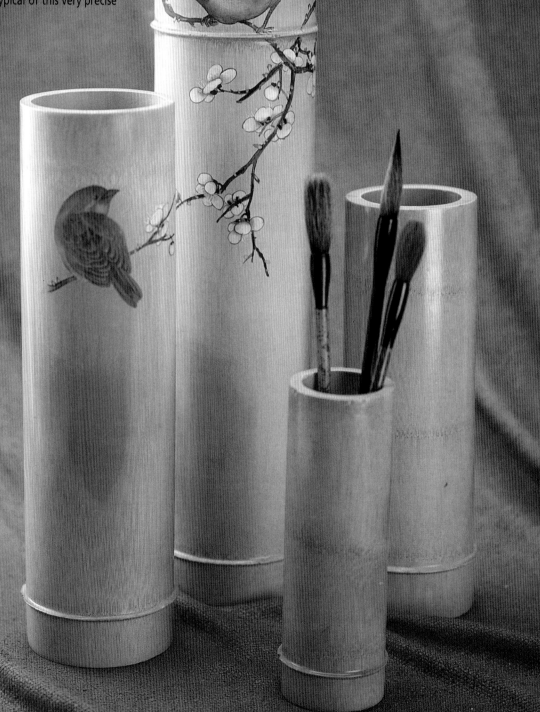

1 Lightly sand the surface of the section of the bamboo that you want to paint. Do not sand too much, just enough to key it.

YOU WILL NEED:

Length of thick bamboo

Fine sandpaper

Small, "red-hair" brush

2 small, mixed-hair brushes

Black ink

Colored pigments:

Orange-brown

Warm brown

Indigo

White

Pale yellow

Mineral green

Seal and red printing paste

2 Using the "red-hair" brush and diluted black ink, start by painting the main outline of the design onto the bamboo. Begin at the top of the pole and work down, painting the lines towards yourself. For this sparrow design, start by painting the bird's beak and move on to do the whole head.

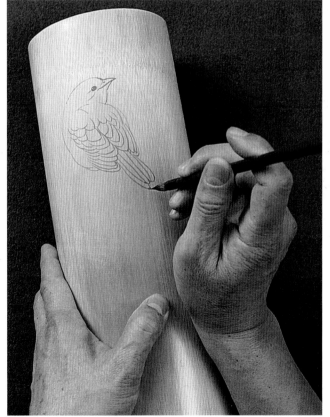

3 Continue painting the bird, working down the body to the tail. The ink dries quickly to a medium gray color. Once you have completed the bird, move on to paint the plum blossom on which the bird is sitting. Paint the outline of the bough and a few blooms.

4 Start applying the ink wash. Dip one small mixed-hair brush into the ink and the other brush into clean water. Again work from the head down, making small brushstrokes with the inked brush. Working quickly, brush over the ink with the wet brush, softening the line and graduating the color to produce shadows and highlights. Paint the whole bird in this way. Paint a light ink wash over the bough and a very light wash at the base of each bloom.

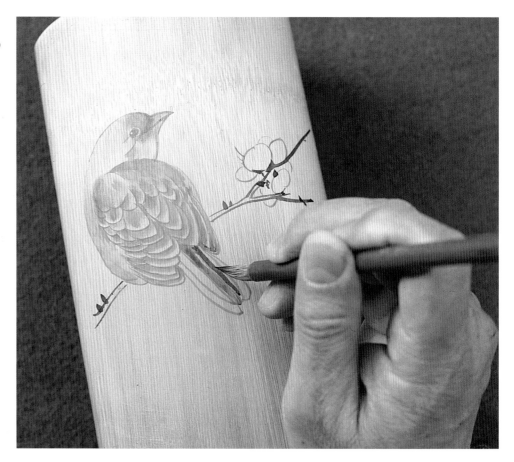

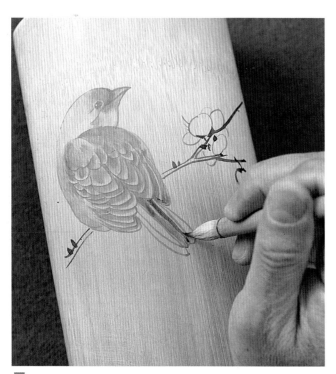

5 Continue building up layers of ink wash to add deeper shadows where appropriate. Here, there are deeper shadows around the head and the tips of the wings where they lie across the bird's back, and at the top of the tail.

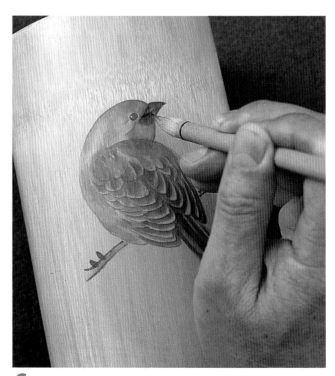

6 Start applying the color. Mix an orange-brown pigment and lightly wash over the bird's beak.

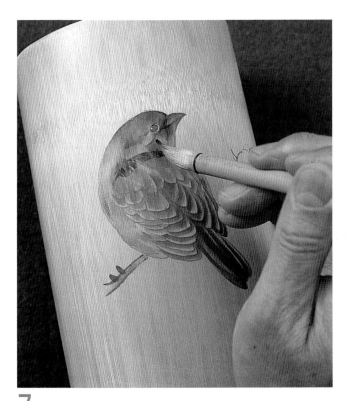

7 Mix a warm brown and paint a light wash over the whole head.

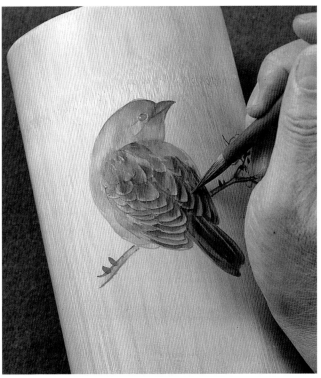

8 Using the same warm brown color, brush a generous sweep of pigment over the edge of the wing. Working quickly, use the wet brush to graduate the color up the wing.

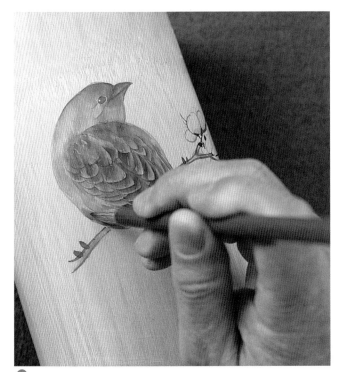

9 Mix a little indigo pigment into the brown and paint along the edge of the bird's stomach. Wash the color over the tummy with the wet brush.

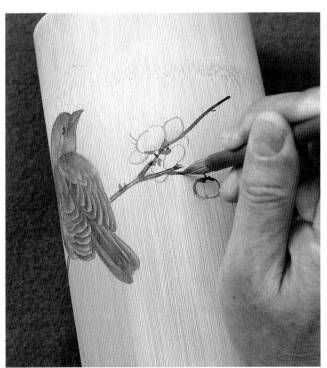

10 Brush a little brown pigment over the ink wash along the bough.

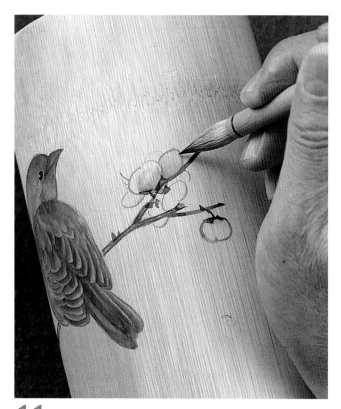

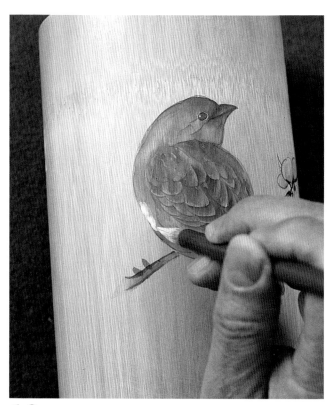

11 Using the brown and indigo mix, paint over the inked section of each bloom. With the wet brush, spread the color up over the flowers.

12 Brush a small circle of white pigment onto the bird's cheek and blend it out with the wet brush. Apply a line of white along the edge of the stomach and blend it across the stomach with the wet brush. Build up the white color so that the stomach becomes paler nearer the tail.

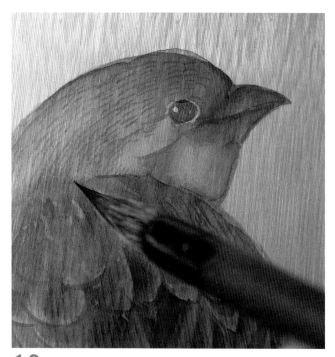

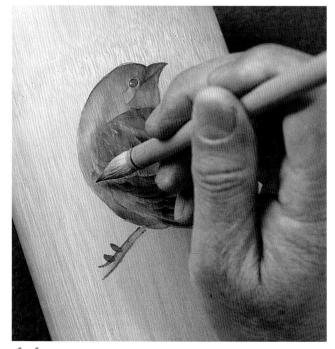

13 Mix up a darker brown pigment and, using just the very tips of the bristles, paint short, very fine lines down each of the feathers. Paint a scattering of lines over the brown section of the head.

14 With some thicker white pigment, paint the same fine lines on the bird's stomach.

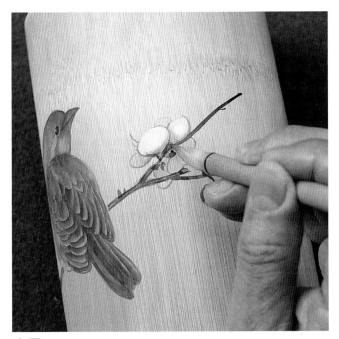

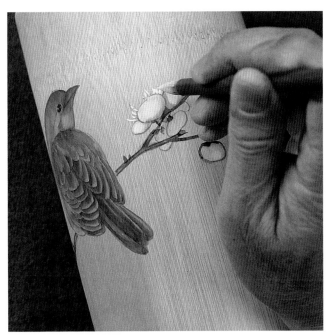

15 Brush a thick layer of white onto each bloom. Using the wet brush, blend the color out over the indigo section.

16 Paint the stamens of each bloom in white.

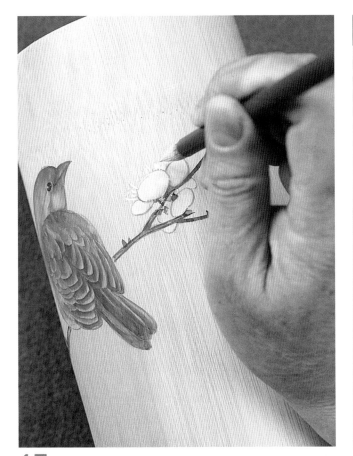

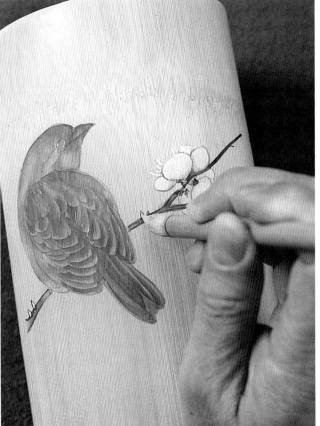

17 Mix some pale yellow pigment, making it a little thicker than previously used. Using just the tip of the bristles, make a tiny dot of color at the top of each stamen.

18 Add luster by mixing up some mineral green paint and making a tiny stroke onto each leaf shoot along the bough using what is known as the "precious-stone" stroke. Seal your work.

bamboo
greetings cards

Bamboo, symbolic of hope and strength in adversity, is represented with sheer simplicity. Coupled with a spare yet delicate color, each picture of wind-brushed leaves seeks to capture its own "moment in time." These color-themed paintings show the bamboo depicted by season; with gold and blue for summer, red and orange in fall, and fresh green in spring.

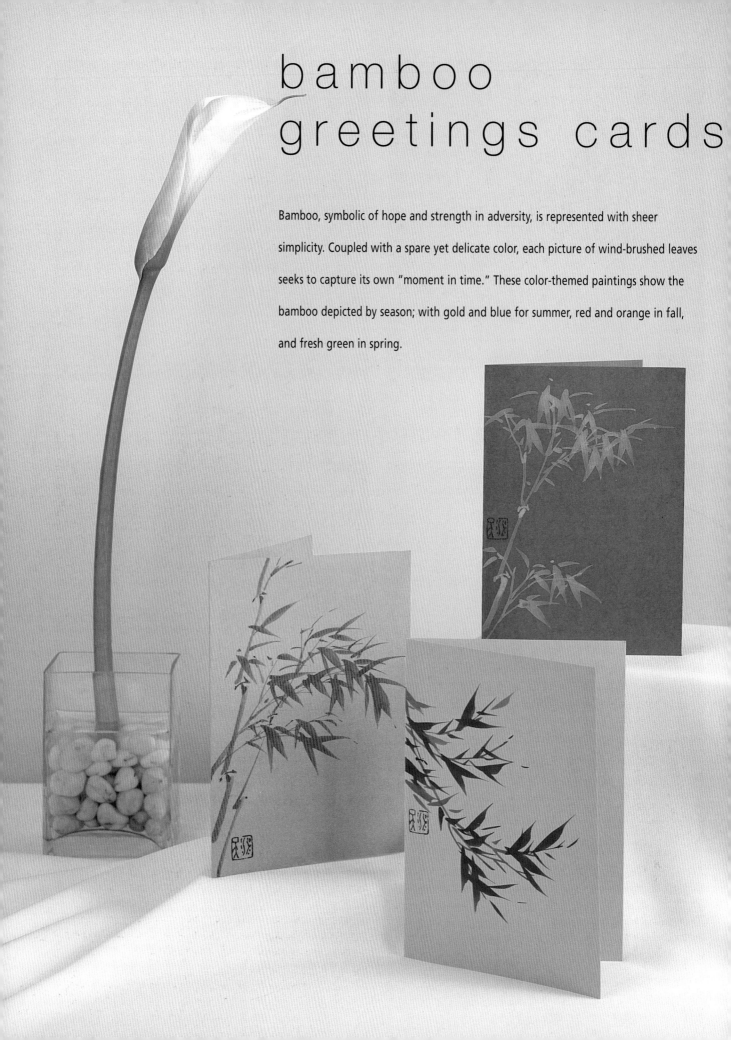

YOU WILL NEED:

Colored card or paper—8 x 8 in (20 x 20 cm)

Medium, stiff-hair brush

Black ink

Colored pigments:

Yellow

Orange

Red—vermilion and carmine

Seal and red printing paste

1 Mix a strong orange ink with a few drops of water in a saucer. Load the brush, and paint the foundations, or thickest stems, of the bamboo in upward, jagged, vertical strokes.

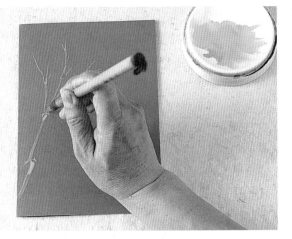

2 Bamboo is often painted seasonally. Paint the smaller stems as if the wind is moving through them; in this painting, the bamboo leaves and stems are rustling in the summer breeze.

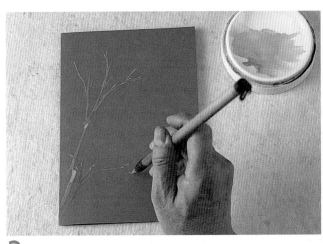

3 Continuing the stem work, paint the thinnest, smaller branches and twigs. Keep the brushwork light but defined, and add two or three thin stems at the base.

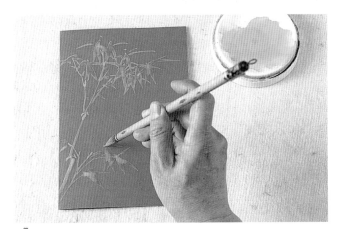

4 Paint the leaves with the downward, right-falling stroke, pulled off sharply at the short base of the stroke. When creating groups of leaves (see page 44), imagine how they work with each other in the breeze .

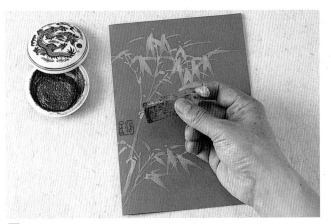

5 Before you place the seal (see pages 62–63), consider how its size and color will affect the proportions of your finished painting. Allow to dry thoroughly before you mount and frame the piece.

cherry fan with grape variation

Paper fans are a traditional feature of Chinese life and have been decorated by brush painters for centuries. Readily available in prefolded Xuan paper with a black border and speckled in gold, they are an ideal base on which to add your own distinctive mark. Transform them into personalized gifts or decorations for the home or dining table, using the most free of the Literati techniques. Don't worry when the ink collects in the grooves of the fan and the colors don't match exactly—it is their gentle, sketched simplicity that makes them so attractive.

YOU WILL NEED:

Paper fan—18 x 9 in (46 x 23 cm)
Small, stiff-hair brush
2 large, mixed-hair brushes
Black ink
Colored pigments:
Indigo
Red—vermilion, carmine, and bright red
Yellow
Seal and red printing paste

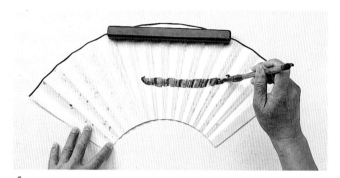

1 Lay the fan flat with a paperweight to secure it. Mix black ink with a touch of indigo to paint the dish. Draw the dish in two strokes. The top is a single horizontal stroke, so pull the soft brush across the fan in a long, smooth line, finishing with a small hook on the right. For the base, darken the ink slightly with a drop of black. Pull the brush across in a shorter, thicker stroke that runs under the center of the first stroke.

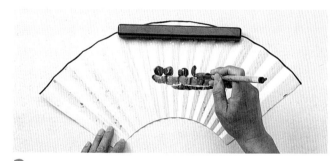

2 Start to create the mound of cherries. Each is made of two crescent-shaped strokes painted opposite each other, leaving a tiny plain patch in the center of each cherry to act as a highlight. Begin by using bright, carmine red for the fruit at the bottom of the pile.

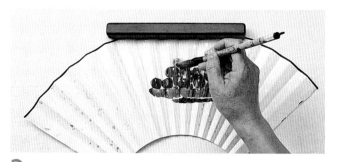

3 Paint the rest of the cherries in a pyramid shape. Vary the tones of the cherries: create a warmer red by mixing in a little yellow, and the cooler reds in the background by slightly diluting the ink.

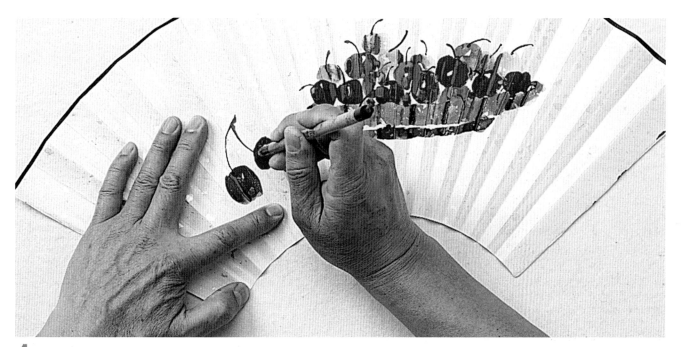

4 Offset two cherries from the bowl to balance the composition, painted in the strongest red of all to emphasize them. Finish by including the stalks in black ink, using fine, but positive, curved line strokes, each one falling at a random angle.

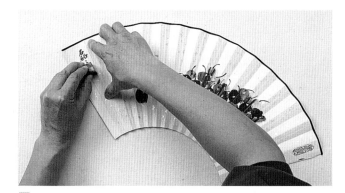

5 Seal your work with red printing paste. Press the seal down firmly. Remember that you can use two seals if you like; consider the composition, perhaps placing one seal either side of the work.

PROJECT COLORS

| pink | orange | warm red | carmine | indigo | black |

Variation: Purple grapes

An alternative decoration to the bowl of cherries is a bunch of grapes. Mix indigo with a little red for the fruit and paint using the strokes described opposite. Connect the fruit with the stalk, adding a dark spot on the grape opposite the stem.

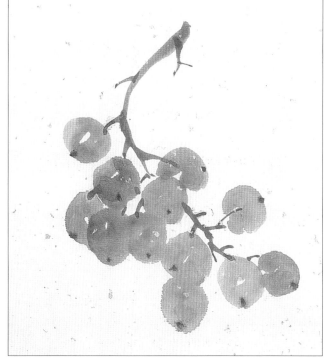

splashed bowl—
kingfisher on lotus

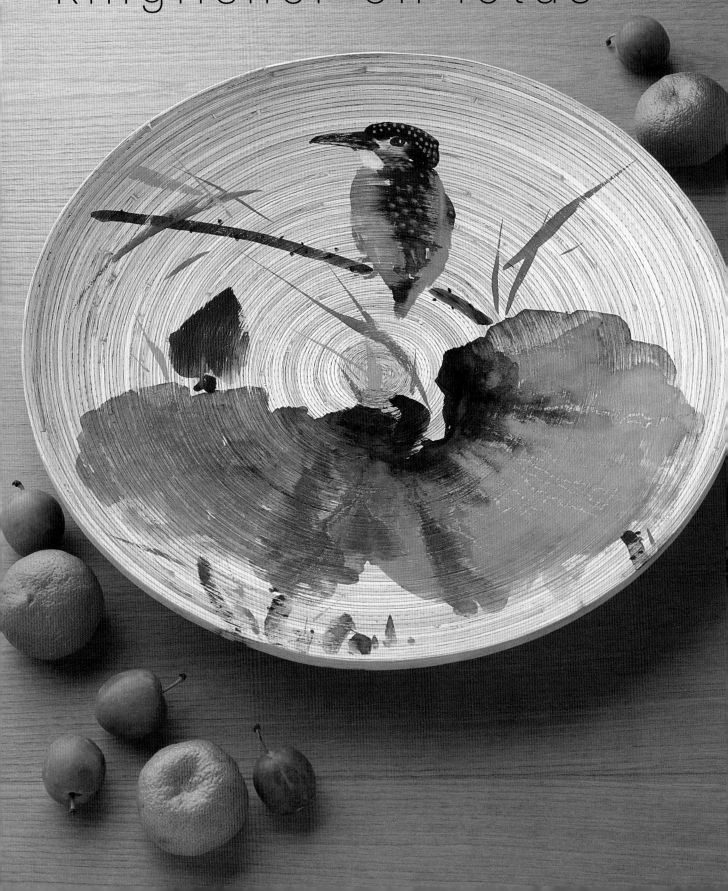

Make a fruit bowl or decorative piece from this simple wooden bowl, personalized with splashed-ink decoration. Because inks do not take to the wood of the bowl as quickly as paper or silk, a completely different effect is created. Paint with a very wet brush, anticipating long breaks for drying between washes, to create an almost abstract image. Although the surface may be different, remember to stick to the other tenets of Chinese painting—place the bird off-center and retain an impression of the composition in your mind even when the ink seems to be running wildly. Perhaps even make a companion piece. The blue kingfisher here is the male, while the female is an equally vibrant green.

YOU WILL NEED:

Wooden or bamboo bowl—
24 in (60 cm) diameter
2 large, soft-hair brushes
Medium, soft-hair brush
Small, stiff-hair brush
Black ink
Colored pigments:
Indigo
Burnt sienna
White
Yellow
Red
Mineral blue
Mineral green

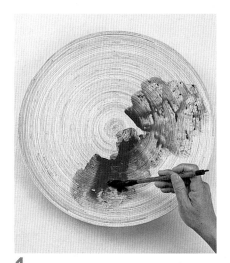

1 Use a big brush, loaded with a large amount of watery, dark ink, to place the lotus leaf over one side of the bowl. Start from the center and work out toward the edges. As the brush is very wet, allow the ink to run loosely across the wood.

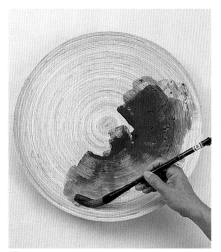

2 Immediately, while the ink is still very wet, add definition to the leaf in indigo, and then burnt sienna. Continue to add layers of ink, letting them merge and spread until the leaf begins to take on a solid form.

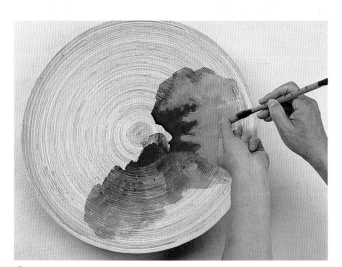

3 Add solid mineral green over the leaf. Load the brush up as densely as possible, and, letting the brush touch the bowl, squeeze ink from the tip with your thumb and index finger while working the ink into the mix.

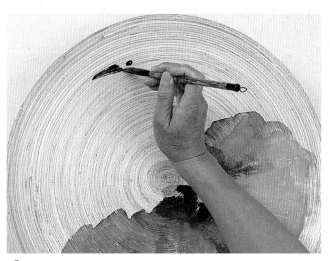

4 When the leaf is dry, use the second big brush to begin painting the beak and eye of the kingfisher.

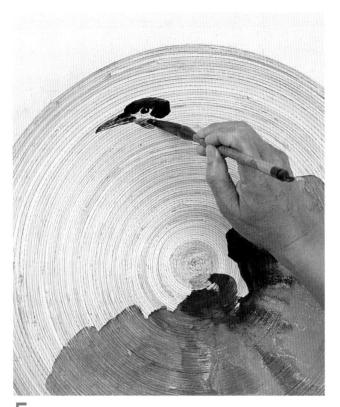

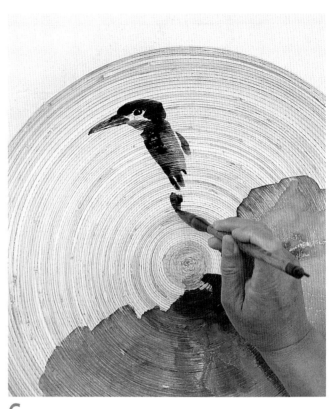

5 Using a thick, soft-hair brush, paint in the brown chin and neck in a mix of burnt sienna. Include the top of the bird's head in black.

6 Sweep in the back and tail using a thick brush in a dark indigo mix, using the pull stroke (see page 32).

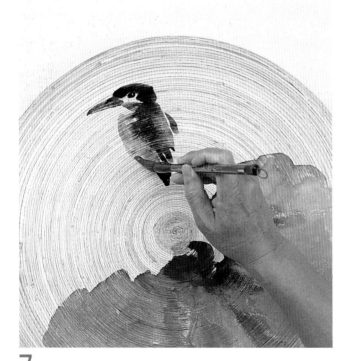

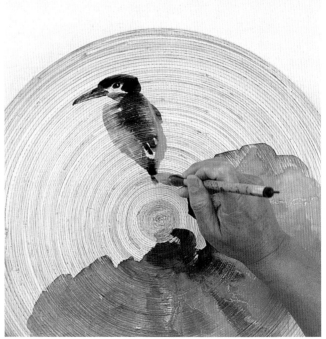

7 Create a pale, warm brown mix from burnt sienna to paint the kingfisher's stomach, sweeping in the color with a large brush all the way from the chin to the tail.

8 Decorate the kingfisher's back and tail in mineral blue ink, allowing the bright color to merge into the previous washes. Also add markings to the cheek and wing.

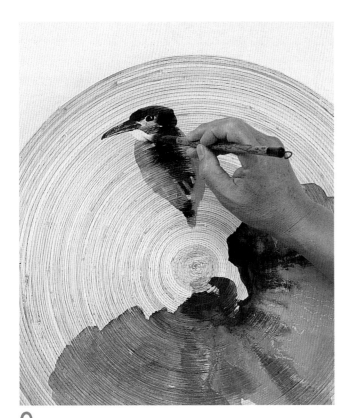

9 Mix white with a little yellow and add the chin.

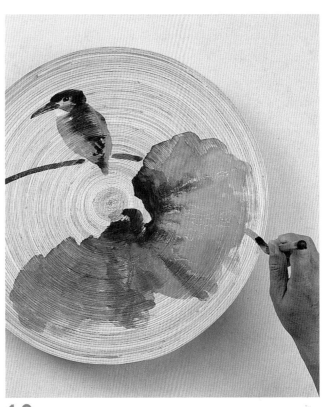

10 Paint the stem using the thick brush and a burnt sienna mix. To ensure the color is even, paint in one single, continuous stroke. As it dries, add dots along its length.

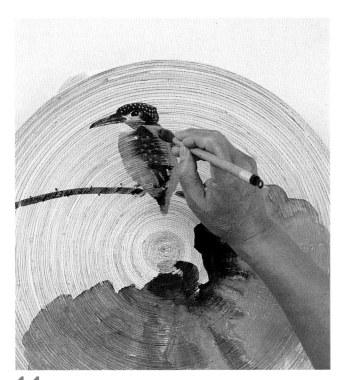

11 Finish the bird by including the claw, in a mix of burnt sienna and red, and the final mineral blue dots on the wings and head.

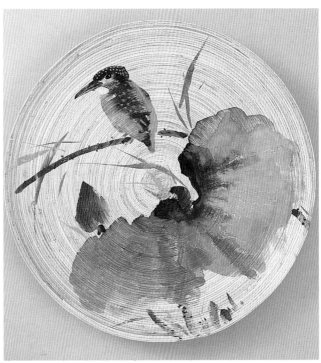

12 To balance the composition add a bud and pale green reeds decorated with splashes of mineral green.

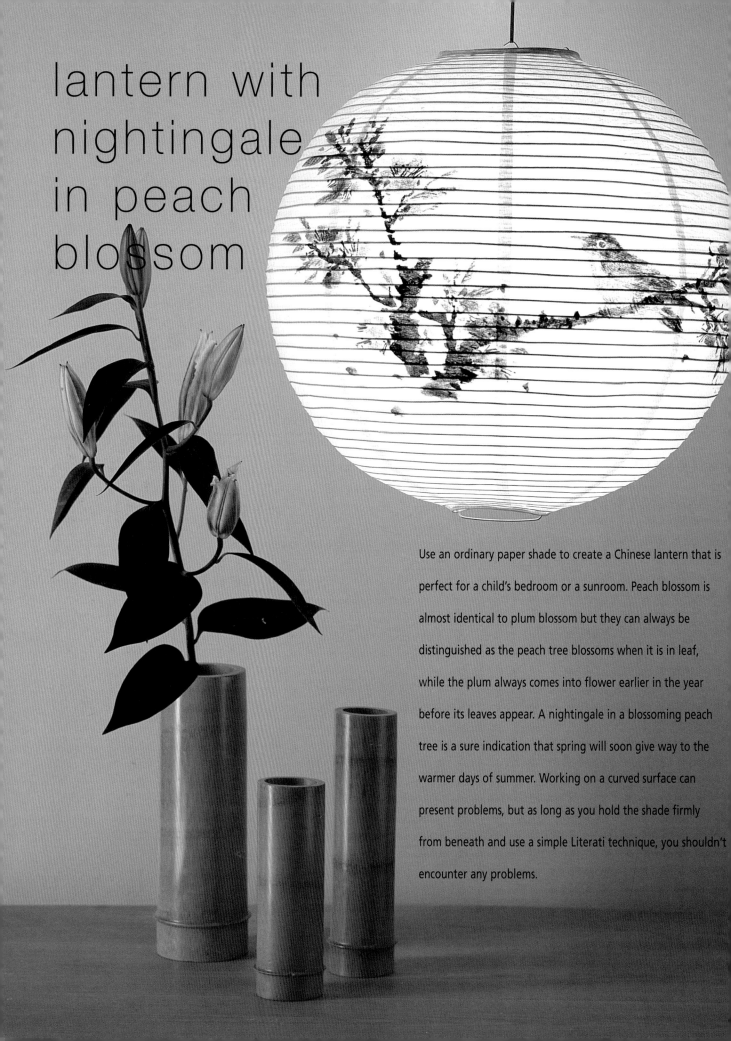

lantern with nightingale in peach blossom

Use an ordinary paper shade to create a Chinese lantern that is perfect for a child's bedroom or a sunroom. Peach blossom is almost identical to plum blossom but they can always be distinguished as the peach tree blossoms when it is in leaf, while the plum always comes into flower earlier in the year before its leaves appear. A nightingale in a blossoming peach tree is a sure indication that spring will soon give way to the warmer days of summer. Working on a curved surface can present problems, but as long as you hold the shade firmly from beneath and use a simple Literati technique, you shouldn't encounter any problems.

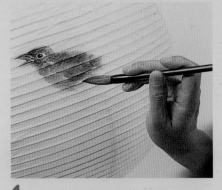

YOU WILL NEED:

Plain, spherical, white paper shade—18-in (46-cm) diameter

Medium, stiff-hair brush

Large, soft-hair brush

Medium, soft-hair brush

Black ink

Colored pigments:

Indigo

Burnt sienna

Carmine red and orange

Mineral green

Yellow

1 Paint the nightingale in three stages using the techniques shown on pages 52–55. Start at the beak, using the stiff brush and a mix of burnt sienna with a little indigo to soften the color. Include the whole of the top of the bird before painting the top of its chest in light ink.

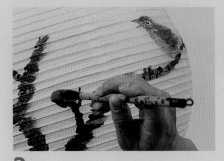

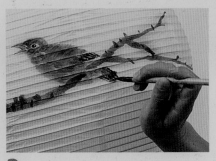

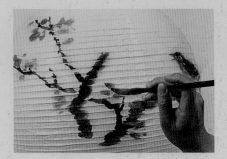

2 Load a mixture of burnt sienna and black ink onto the large, soft-hair brush to paint in the main branch, running it closely under the body of the bird. Follow the techniques for plum blossom on page 34 for guidance.

3 Paint the bottom of the bird beneath the branch, using a pale wash of indigo for the stomach, burnt sienna for the tail, and ink for the darkest of the tail feathers.

4 Using a pale mix of carmine and water on the medium, soft-hair brush, paint the peach blossom in short, thick strokes. Don't overload the brush with pigment, but keep the tip densest. The flowers are almost identical to plum blossom, apart from their sharp tips, so use a similar method, moving the brush in a dabbing motion.

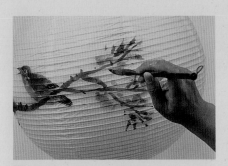

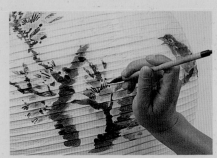

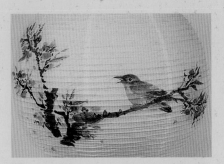

5 Create the leaves. Paint in the main clusters in green, mixed from indigo and yellow.

6 Using the tip of the stiff brush, draw in the veins on the leaves in indigo mixed with a tiny amount of black. Paint in the stamens in a very dark mix of black and red with light, long strokes, and add the calyxes as small dots in the center of the larger flowers.

7 Complete the bird by including a claw in orange, back feathers highlighted in burnt sienna, and tail feathers in indigo. Finally, add the traditional turquoise signs of spring with small dashes of mineral green, scattering them over the branch and blossom.

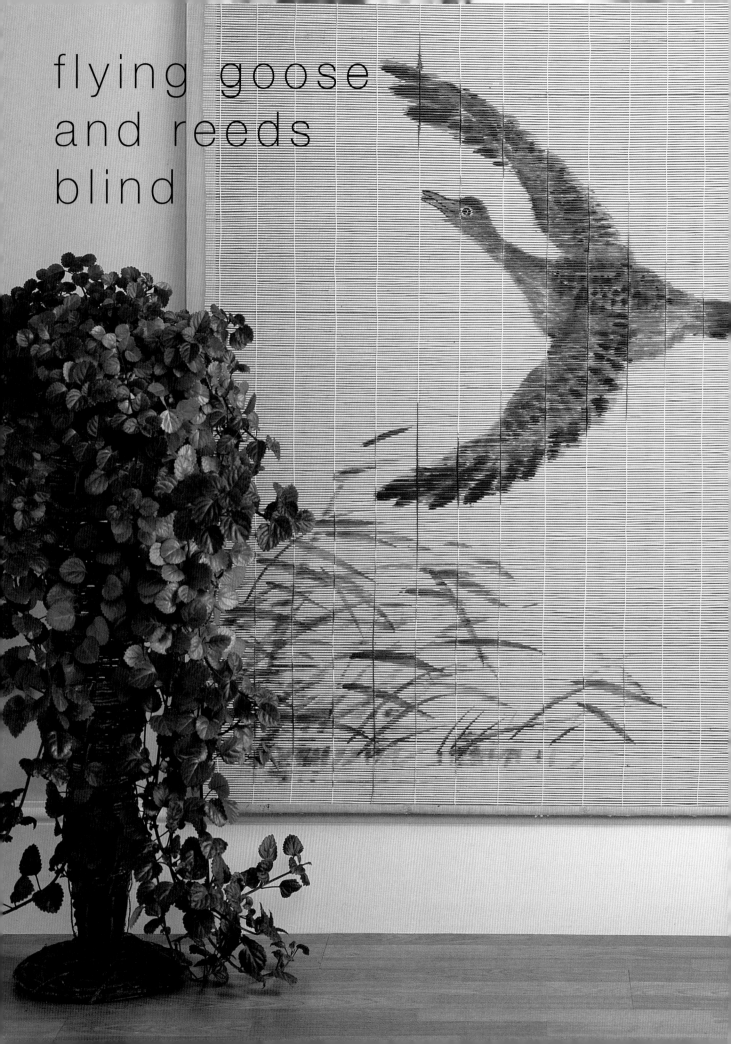

flying goose
and reeds
blind

This powerful and gentle scene of a goose flying over reeds has been painted on a blind to create an extra picture that suddenly decorates a room after dark. The inks take to the bamboo slats of the blind extremely well, though take care they are closely fitting when you begin. Even on such a large scale, the basics of bird painting still apply (see pages 50–53). Create the feeling of movement with the slow, rhythmic beating of the wings by painting the goose at the very end of a wing beat with the outer flying feathers curved inward, showing the huge effort the large bird uses to keep itself airborne.

YOU WILL NEED:
Slatted blind—54-in (135-cm) drop
Large, soft-hair brush
Medium, stiff-hair brush
Medium, soft-hair brush
Black ink
Colored pigments:
Burnt sienna
Yellow
Indigo
Green
Matt acrylic varnish

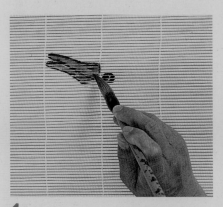

1 Start by outlining the beak and eye in black with a stiff, fine-tipped brush. Fill in with a wash of burnt sienna and yellow, using a medium, soft-hair brush.

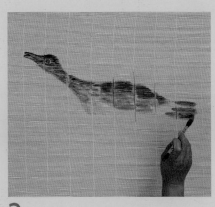

2 To paint the head, mix burnt sienna with ink and use the larger soft brush, sweeping away from the beak. Continue to move along the neck and and further down the bird's back, steadily darkening the mix by including traces of indigo.

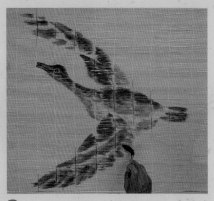

3 Use a similar color to paint the wings, emphasizing the beating motion by lengthening the tips of the upper wing with broad dot strokes (see page 33). Use the same stroke to extend the outer feathers of the bottom wing.

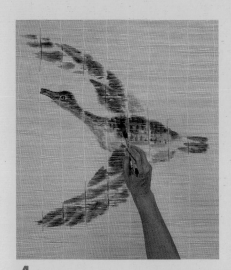

4 Emphasize the shape of the chest and rump by adding more indigo to the mix. Cover the body with vertical dot strokes to shade using the smaller soft brush.

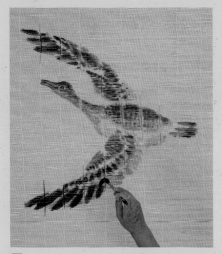

5 Highlight the tail and wingtips with ink. Work in a curve to show the wing shape covering the flying feathers with ink.

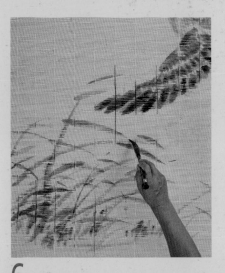

6 Moving to the bottom of the blind, add the reeds in green, using the movement of the leaves to indicate a breeze. When dry, cover the entire blind in matt acrylic varnish.

decorative kite with goldfish design

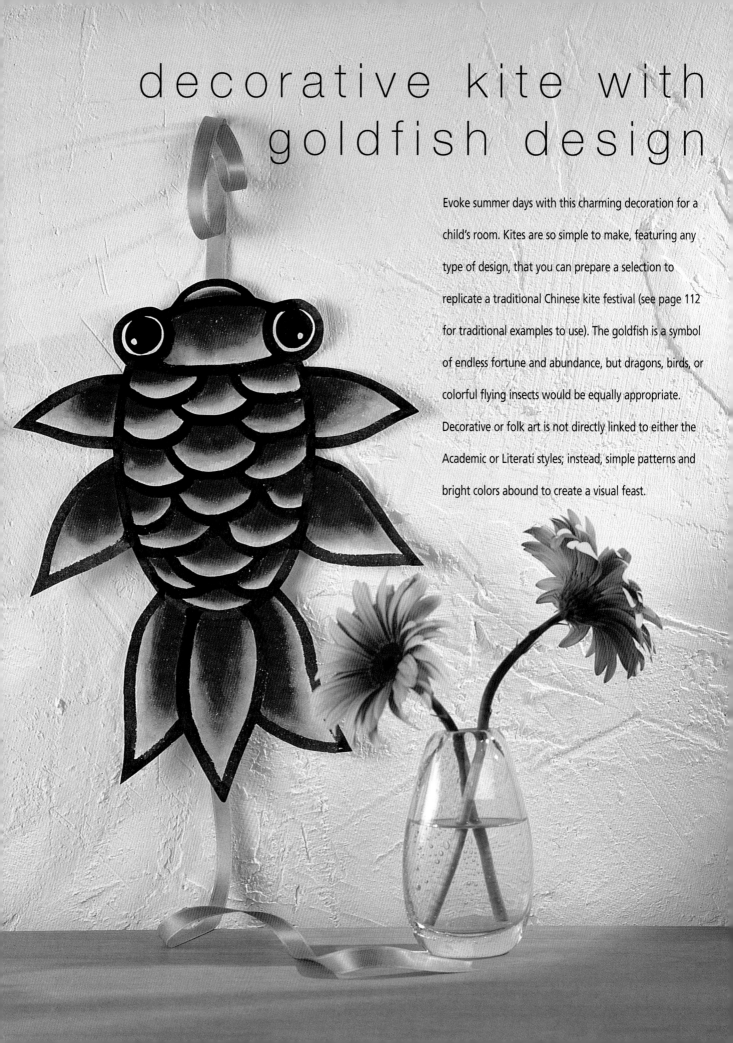

Evoke summer days with this charming decoration for a child's room. Kites are so simple to make, featuring any type of design, that you can prepare a selection to replicate a traditional Chinese kite festival (see page 112 for traditional examples to use). The goldfish is a symbol of endless fortune and abundance, but dragons, birds, or colorful flying insects would be equally appropriate. Decorative or folk art is not directly linked to either the Academic or Literati styles; instead, simple patterns and bright colors abound to create a visual feast.

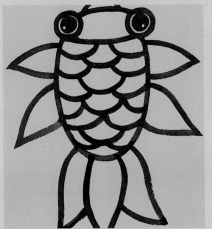

1 Use the stiff-hair brush to trace the outline of your design in ink from the template onto the paper.

YOU WILL NEED:

Thick, sized, Xuan paper—18 x 12 in (46 x 30 cm)

Medium, stiff-hair brush

2 medium, soft-hair brushes

Black ink

Colored pigments:

Red

Yellow

Plain kite frame

Masking tape

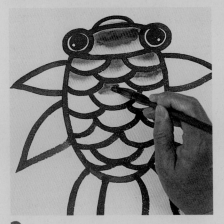

2 Ink wash color (see page 31) into each scale in turn using two medium, soft-hair brushes. Load one brush with red pigment and paint along the top of a scale.

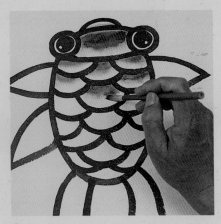

3 Load the second brush with water and drag the pigment across the lower part of each scale, gradating it. On the fins, paint along the inner edges and wash out toward the points.

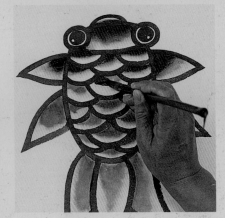

4 When dry, go over each scale again, using a stronger red to emphasize the tone.

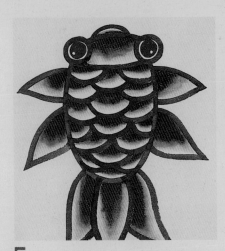

5 Take a simple kite frame and, following the instructions provided, bend to the circumference of the kite, fixing with wire and protecting any points with rubber bungs.

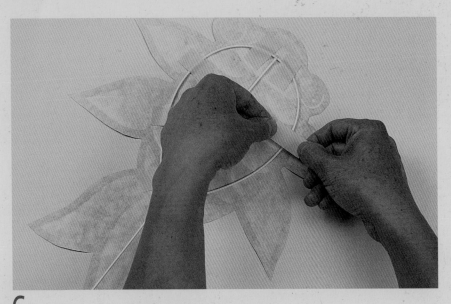

6 Cut out the kite and affix to the frame with masking tape.

zodiac mobile

Created with decorative folk art motifs, this mobile is a bright and vivacious representation of the Chinese Zodiac. Each of the animals represents a year in the twelve-year astrological cycle. The Chinese ignore Western preconceptions about mice and snakes; in their zodiac all the animals are equally admired. The simple designs, which are both easy to make and paint, also hint at the color of Chinese New Year festivals and will be a charming first feature for a baby's room.

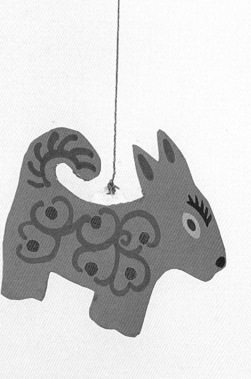

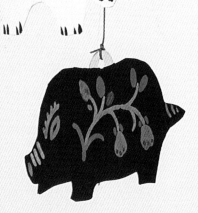

YOU WILL NEED:

Thick card stock

Pencil

Scissors

Punch

Medium brush

Poster paints/gouache

2 x 18-in (46-cm) thin batons

4 x 9-in (23-cm) thin batons

Thread

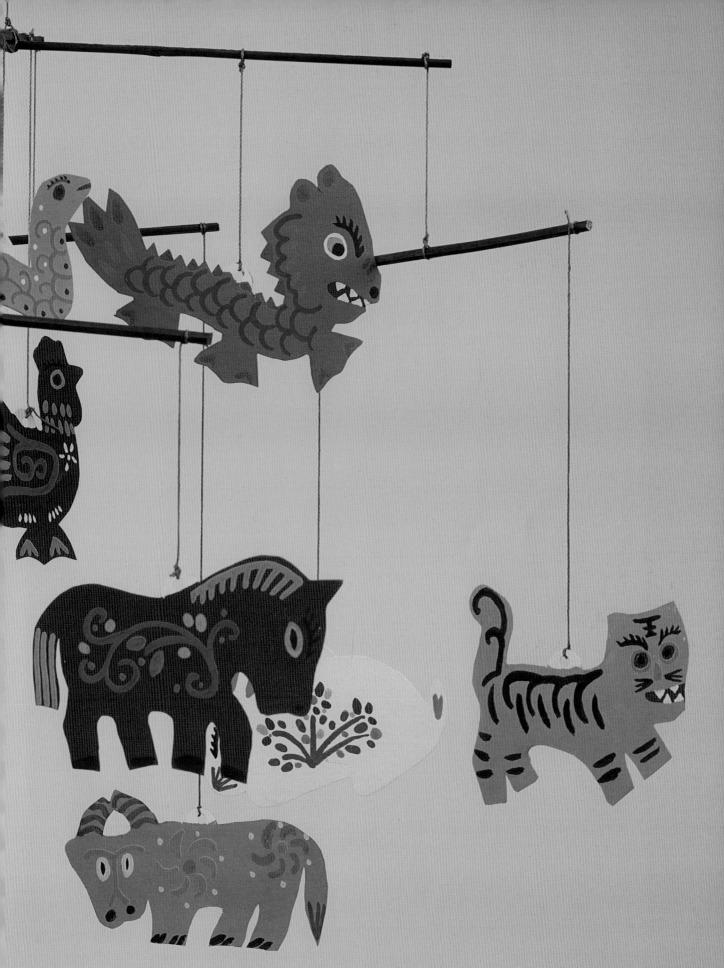

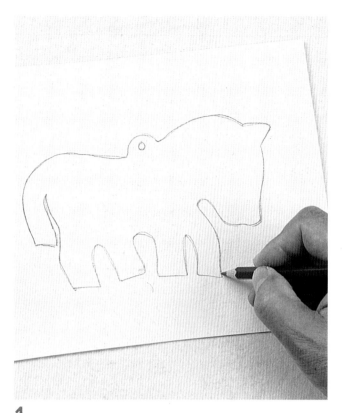

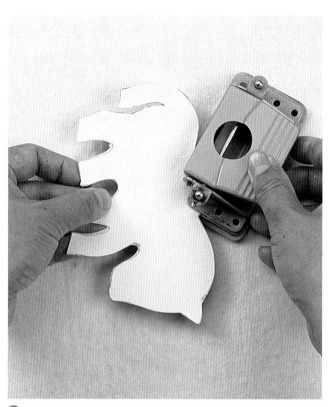

1 Using the templates on page 113, trace the animal outlines in pencil onto thick card stock, adding a tab along the top edge, each one positioned so that the animals will balance level when hanging.

2 Cut the shapes out from the card with sharp scissors and then use the punch to create the hole in the center of the tab from which the animals will hang.

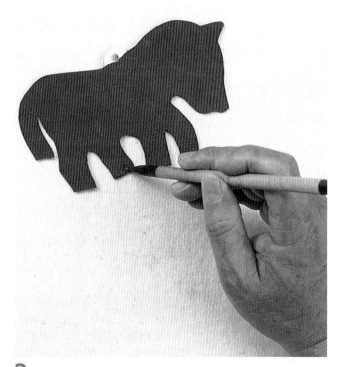

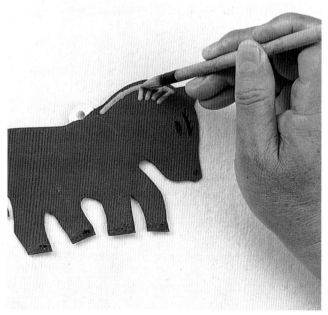

3 Paint the base coat in a solid color, leaving only the tab blank. Use poster paint or gouache as ink will not form a strong enough base on which to apply the decoration.

4 Decorate with folk art motifs, painted in strong, pure colors for the greatest contrast. Start with the eye and mouth to fix the character of the animal in your mind. Then paint all details of the same color in turn.

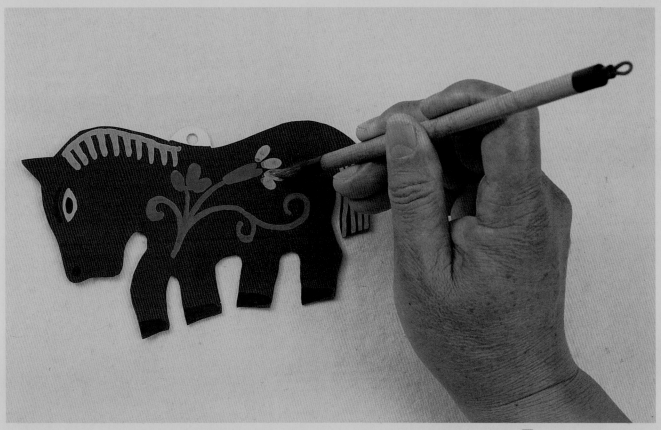

5 Turn over and repeat the decoration on the reverse of the card stock.

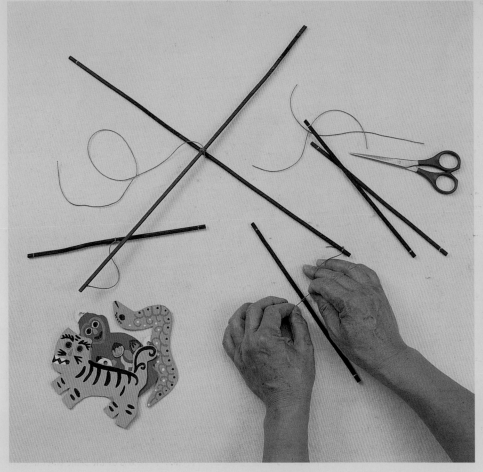

6 Construct the frame by binding two 18-in (46-cm) batons in a cross with thread. Hang short lengths of thread from the ends and knot the loose ends around the middle of the 9-in (23-cm) batons. Fix lengths of thread to the holes punched in the tabs of all the animals, securing one at each end of the shorter batons and the remaining four on the longer batons, halfway along each arm.

traditional kite designs

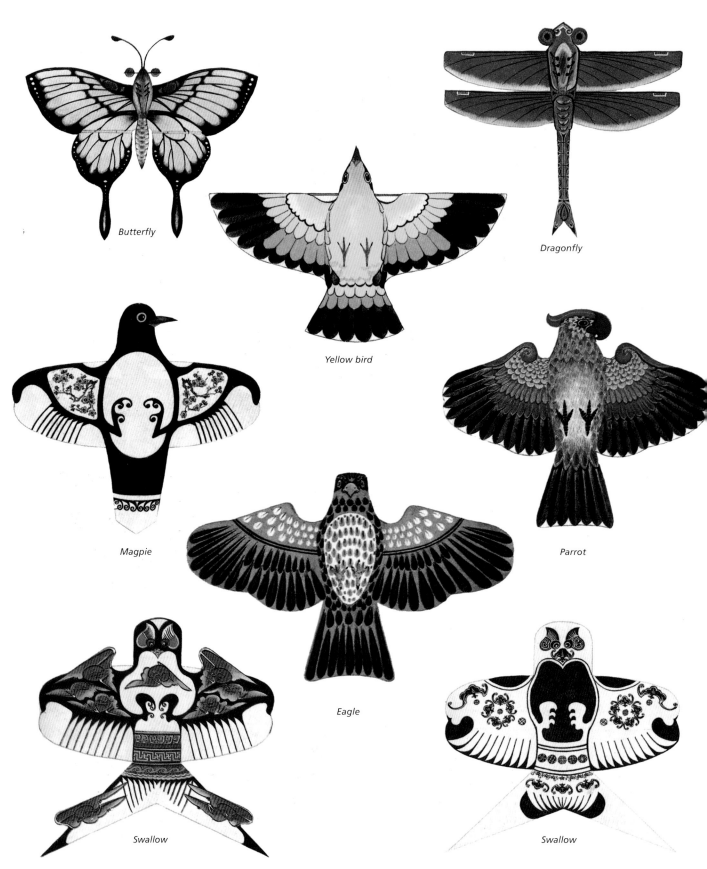

Butterfly

Dragonfly

Yellow bird

Magpie

Parrot

Eagle

Swallow

Swallow

永 THE PROJECTS

zodiac templates

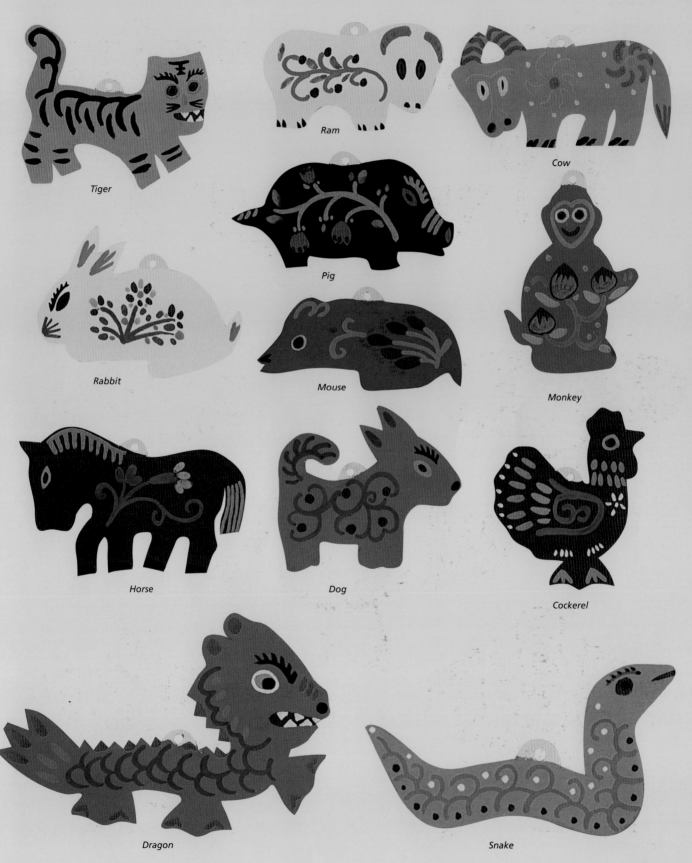

Tiger

Ram

Cow

Rabbit

Pig

Mouse

Monkey

Horse

Dog

Cockerel

Dragon

Snake

mounting

Only when a painting is mounted can it be seen in all its glory. As paper distorts when ink is applied, its fibers need to be stretched back to their original structure, allowing the full colors of the picture to reveal themselves. By fixing the painting onto a second layer of paper before being placed in a frame, its shape is restored and colors enriched.

YOU WILL NEED:

Backing paper
Water spray
Piece of fabric or toweling
8 oz (250 g) wallpaper paste
Card stock
Palette knife
Soft-bristled hand brush
Stiff-bristled hand brush
Palette knife

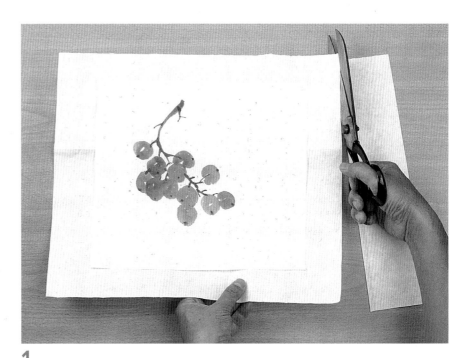

1 Prepare the backing paper from the same type of paper as the artwork, or either xuan or mao bian paper. Allow a border of at least 1 ½ in (4 cm) all around the backing sheet.

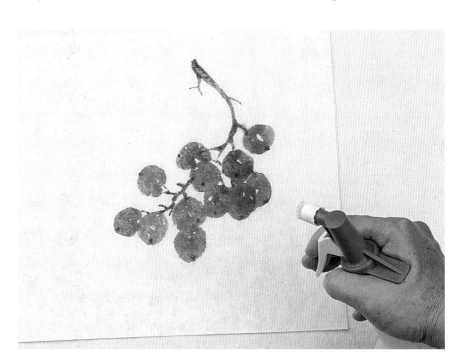

2 Place the artwork face down on a piece of fabric or towelling and dampen the back lightly and evenly with the water spray.

3 Carefully lift the artwork off the fabric (the paper is extremely delicate when wet) and place it face down on a hard, waterproof surface. Use the soft brush to cover the back with paste, working gently outward from the center, first up and down and then finally to both sides.

4 Continue working from the center, finishing with diagonal strokes to the corners. Repeat the process, ensuring that the paste is evenly spread across the entire artwork.

5 Align the backing paper with the artwork, placing the bottom right hand corner 1 ½ in (4 cm) out from the artwork to allow for the border. Hold the paper away from the painting and use the stiff brush to press the two sheets together.

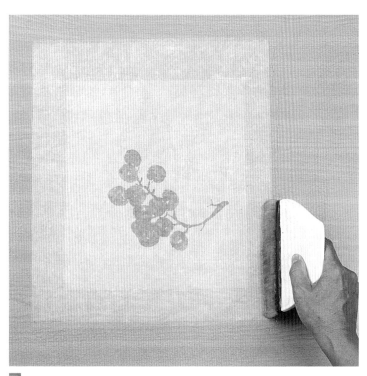

6 Work over the backing gently in a diagonal motion until no air bubbles or creases remain.

7 Use the soft brush to apply paste in a ¹/₂-in (1.5-cm) band all around the edges of the backing paper.

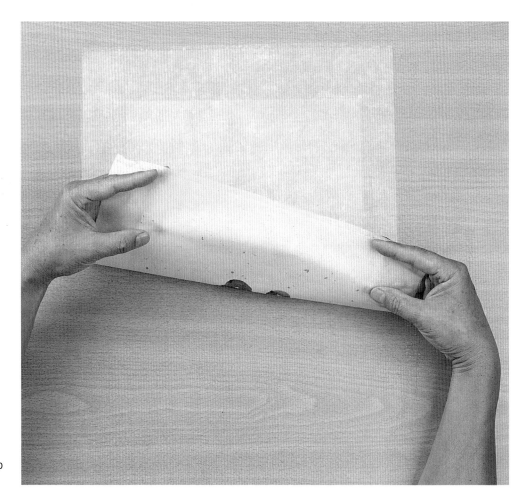

8 Gently lift the painting away from the surface, taking great care not to tear it at this stage. Use a palette knife to help lift up the first corner cleanly.

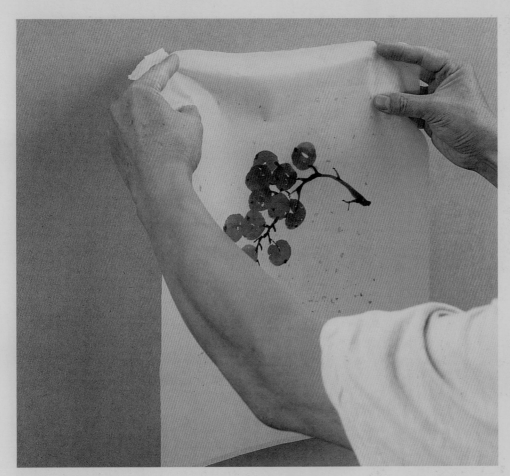

9 With the artwork now face up place it on a sheet of board propped vertically against a wall.

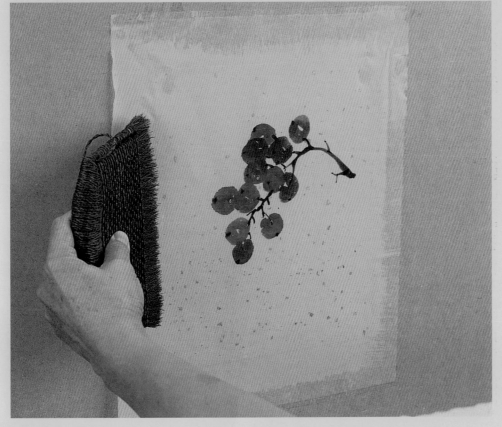

10 Brush the edges to fix the paste, ensuring that they are straight and unwrinkled. Before sealing the last corner, blow a little air between the paper and the board to ensure that the actual painting doesn't stick to the board. Leave for a few days to stretch and dry before cutting away the picture.

墨香盈室秋色滿窗

養花得蝶種樹成蔭

春風常在心闊天寬

calligraphy poems

A painting is only complete when it embodies the "Four Perfections"—the image, a piece of poetry, the calligraphy used to transcribe it, and the signature or seal. To perfect your favorite pieces, add a poem, phrase, or proverb that will help the viewer share the meaning of the image. Traditionally, each of the "Four Gentlemen"—the blossom, orchid, bamboo, and chrysanthemum—is matched with a particular type of poetry. The elegant orchid, for instance, can be paired with Zen meditations on the nature of beauty and calm, while sprays of bird-filled blossom are interwoven with motifs that inspire free expression of the spirit. China has a long history of adding seasonal sayings for year-round wisdom. A popular summer poem reminds us: "I look after my flowers, and they give me butterflies. I plant my trees, and they give me shade." Inscriptions can be used individually or in pairs, as long as your calligraphy choices are placed in the correct position, whether vertically, horizontally, or woven into the image (see pages 62–63 for guidance).

blossom

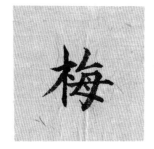

Plum Blossom

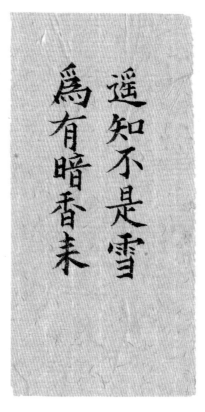

I know the lands in the distance beyond are not snowy,
Because a secret fragrance drifts to me from there.

A few shadows of branches lie across the shallow clear stream,
Their secret fragrance floating away under the moonlight.

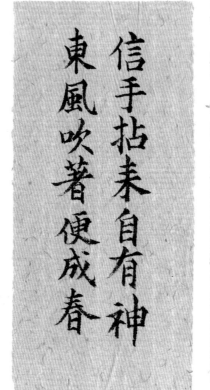

The blossom that appears from my brush will be transformed into spirit when the wind blows from the east.

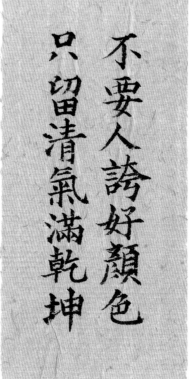

I do not need those who praise me for my beautiful colors,
I only want to keep the spirit of purity throughout the world.

orchid

Orchid

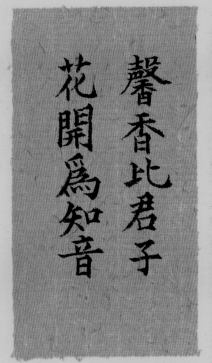

馨香比君子
花開爲知音

Fragrance can be a symbol of the gentleman:
The flower only blooms for the closest friend.

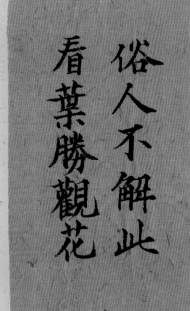

俗人不解此
看葉勝觀花

A vulgar person will never understand that the study of leaves can be more enjoyable than watching flowers.

滌盡塵心悟畫禪

Cleanse my heart completely,
So I can understand the Zen of art.

不覺香在室
推窗蝶飛来

When I stay inside my room too long, I forget how fragrant this place is,
Until I push open the window, and the butterfly flies in.

bamboo

Bamboo

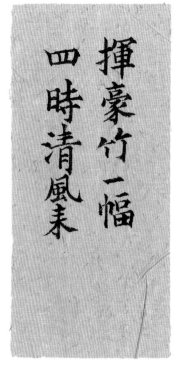

When I paint a bamboo, I am able to enjoy the fresh wind in all four seasons.

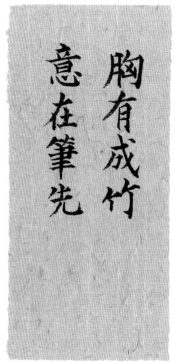

The bamboo is already in my heart: The movement of my brush just follows the spirit.

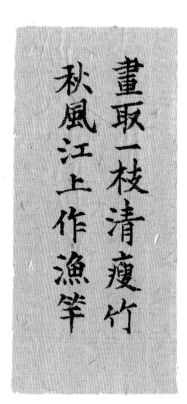

The long, thin bamboo pole that I painted can be used as a fishing rod on the river in the Fall.

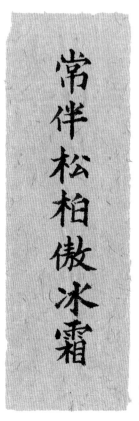

Accompanying the pine, bamboo stands tall with pride through ice and frost.

chrysanthemum

Chrysanthemum

When I can pick a chrysanthemum from under the east fence, I am happy to see the mountain in the south.

I realize an idea is true and original when I want to study and explain it but find I have already forgotten what to say.

When the flowers are blooming, there is my bosom friend. When my brush is dancing, there is the sincerest emotion.

The fall wind is blowing, new wine is ready made. It is time to enjoy the chrysanthemum flowers.

spring

Spring

My heart is open and my world is broad, because the spring wind is always blowing.

The flowers are all blooming, spring has returned to the world.

The fragrance of flowers and the singing of birds are my poems.

When spring comes I do nothing but care for my flowers.

summer

Summer

When the rain is over, I like to look at the mountains.
When the wind comes, I listen to the singing of the birds.

I look after my flowers, and they give me butterflies.
I plant my trees, and they give me shade.

Summer wind sends the fragrance of lotus floating across to the water pavilion.

I have beautiful flowers in my garden;
With a peaceful heart, the body is cool.

fall

Fall

The drifting fragrance of flowers keeps my guests with me,
Let my poetry be sent to them on the same wind.

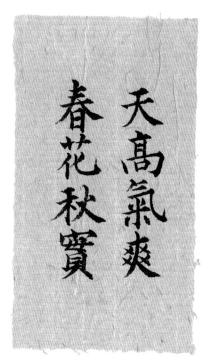

Under the high sky and the cooling air of fall, Spring flowers become autumnal fruit.

Frosty leaves can be more beautiful than flowers in spring.

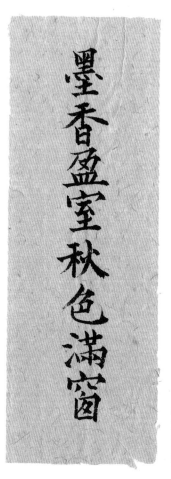

As the fragrance of ink fills my studio, The colors of Fall fill my window.

winter

Winter

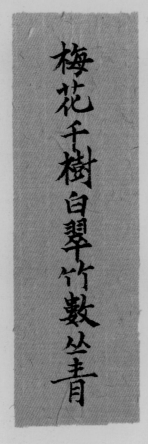

梅花千樹白翠竹數叢青

Even when thousands of
blossom trees are white,
A handful of bamboo
bushes remain green.

歲寒三友

Three friends
in the cold.

風入寒松聲自古
老雁一鳴霜滿天

When the wind can be heard
blowing through the cold
pine, it will be cold,
But when the old goose cries,
frost will cover the world.

霜雪中見松竹心

You can see the
hearts of pine and
bamboo in the frost
and snow.

index